To Andrew Martind[...] [...]y
day spent in Norwich, wi[...] [...]

fondly
from

Alice Low-Beer

GEORGES ROUAULT – ANDRÉ SUARÈS
CORRESPONDENCE 1911 - 1939

WORKS BY ANDRÉ SUARÈS

TROIS HOMMES, Pascal-Ibsen-Dostoïevski.
ESSAIS.
PORTRAITS.
REMARQUES.
LE BOUCLIER DU ZODIAQUE, illustrations by Galanis.
HÉLÈNE CHEZ ARCHIMÈDE.
IGNORÉES DU DESTINATAIRE. Unpublished Letters, foreword by
 Armand Roumanet.

ANDRÉ SUARÈS and PAUL CLAUDEL

CORRESPONDANCE (1904-1938), foreword & notes by Robert Mallet.

GEORGES ROUAULT — ANDRÉ SUARÈS CORRESPONDENCE 1911 -1939

Translated and edited from
the French by
Alice B. Low-Beer

Introduction by
Marcel Arland

ARTHUR H. STOCKWELL LTD.
Elms Court Ilfracombe
Devon

I am much indebted to my friends who have helped and encouraged me in so many ways, and especially to Elsie Green, M.B.E. and to my daughter Friedl Brown.

ISBN 0 7223 1621-6
Printed in Great Britain by
Arthur H. Stockwell Ltd.
Elms Court Ilfracombe
Devon

FOREWORD

During his numerous peregrinations, Georges Rouault took infinite care of the letters which André Suarès sent him over the years. After having settled in Sarthe in 1939, he was compelled to leave. The Germans camped in his studio.

It was in the attic, where a few months later we found cut-up paintings used as blinds for passive defence, broken ceramics, split tubes of paint, puddles of linseed oil, ripped open packets of manuscript, everything in a hopeless mixture, sprinkled with pastels and strewn with chicken feathers. One by one the letters of André Suarès had to be recovered.

As for those of Georges Rouault, they had been kept by André Suarès with the greatest care. The writer, it is well known, was threatened and pursued during the Occupation. He hid in Antibes, while at his Parisian residence, in rue de la Cerisaie, everyone lived in fear of the Gestapo. One night, Mme Kampmann* took all the manuscripts of André Suarès, including the letters in question, to the attic. At three o'clock in the morning her work was interrupted by violent knocks at the door . . . they were from neighbours inconvenienced by this unusual disturbance.

Suarès died in the Varenne in 1948. A few months later Mme Suarès-Kampmann let Georges Rouault know of the existence of the letters which remained intact. She wanted to

*Who some time afterwards became Mme André Suarès. She devoted herself for more than twenty years to the work of André Suarès to which she has dedicated herself from then on.

entrust them to him, with a view to their possible publication. He was able to re-read a great many of them during our stay in the South. He sorted them out and shortened them. I read them aloud for two hours daily; he interrupted me frequently to point out mistakes and repetitions . . . and to call on my mother's excellent memory to ask her a date or for information, to evoke mutual recollections.

He also wanted me to re-read all Suarès' letters. They enraptured him . . . more than ever, taking into account the passage of time, he measured the rare perspicacity of the great and unrecognized writer, who believed in him from 1911 onwards and the moral and spiritual support which he had given him.

From that moment onwards, Georges Rouault also wished for the publication of the *Correspondence*. But he had doubts about the value of his own letters, the literary superiority of Suarès seemed to him overwhelming. He then took advice from Marcel Arland, whose subtlety and independent judgment he valued. Reassured, he entrusted him with the presentation.

Georges Rouault was unable to revise all the letters; we finished reading them in view of the publication he envisaged, taking the liberty of adding a few notes.

Thus we are carrying out one of his last wishes.

Isabelle and Geneviève Rouault.

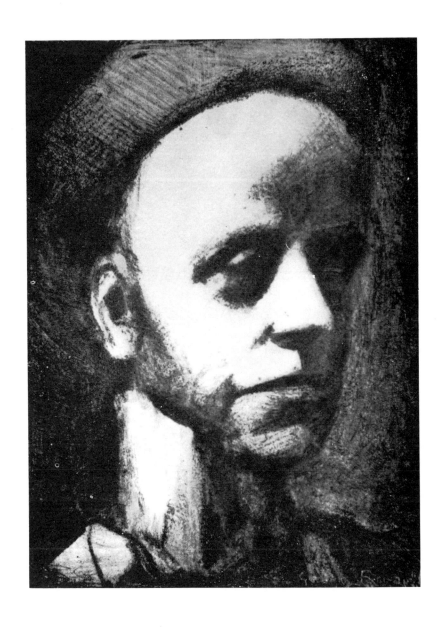

GEORGES ROUAULT
A self-portrait

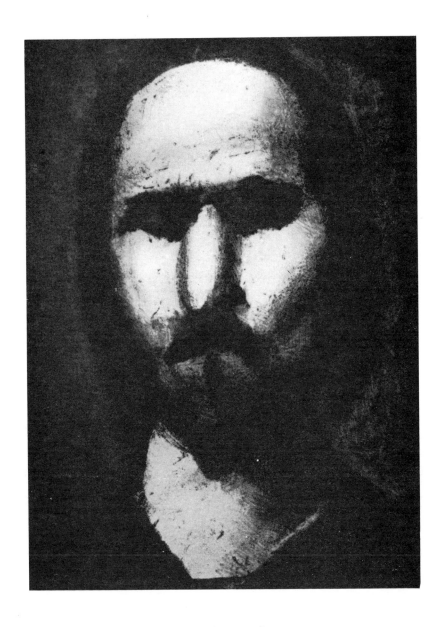

·*ANDRÉ SUARÈS*
Portrait by Georges Rouault

INTRODUCTION

André Suarès died in 1948; Georges Rouault ten years later.

They had known each other since 1911.

Since the painter wished for the publication of their correspondence, it was probably for the purpose of reviving a long friendship and thereby paying homage to a valued friend who stood by him in difficult times.

They strike us first by their contrast in style and in manner, even in the contents of their letters. Suarès, whatever he writes, does it as a writer; he composes (not that he tries to, it is his nature), with polished eloquence. He does so with imperious gravity, even when talking of a cold — but he does not talk much about it and confides almost nothing of his daily life, obsessed as he is above all by his great themes of art and ethics.

There is certainly no less passion in Rouault. He often sets out vehemently the same themes as his friend, but he does so without reservation with his natural spontaneity and exuberance. He doubtlessly enjoyed writing: interminable letters, essays, souvenirs, poems, legends for his engravings; but he is a painter and it is to his work as a painter that he devoted all his art, his scruples and his patience. He is not concerned with the impression he gives in his letters unless complete sincerity in itself betrays in a way an impression he

wants to convey above all. He writes as the mood takes him, raises issues as they come to his mind, pell-mell, his inveterate obsessions, his works, the artist's struggles, his vexations or his joys: an illness, a birth, a mourning, a journey, an encounter, a quarrel, a lecture, a description of childhood or of the studio. He is grieved, recovers, bursts out, rebukes, relents, jokes, suddenly seems the soul of reasonableness or adds humour to lyricism in a kind of popular complaint. In short, everything seems as if all those letters were but one, always resumed, never completed. This is not done without confusion or clumsiness (neither moreover without sudden and rigorous original expressions). But it is thus that we do not cease to feel his immediate presence. For those who know the painter only, here is the man, here the conditions in which his work was formed and of this one would be unable to find a more true illumination.

It seems that it was not without difficulty that Rouault and Suarès came to each other. The painter was forty and the writer three years older. Rouault made the first move and asked to be received. How is this appeal to be explained, coming from a man who chose solitude as one of the essentials for his work?

Had he died in 1911, Rouault would have been a great painter already, the painter of prostitutes, judges, clowns and tormented faces. But even though his paintings aroused some fervent admiration he did not keep abreast of his time. And how many former admirers did he not disappoint who reproached the favourite of Gustave Moreau of the 'Chenavard Prix', the harmonious painter of grand scenes of the Holy Scripture, for repudiating his first learnings and his true gifts in order to become a painter of the grotesque or of dramatic ugliness. If only he had had the conviction that he was completely fulfilled. But in his life did he ever have it? Happy about a painting, a progress, a stage, but all the more eager to progress further. What he could achieve until 1911 served him only to measure what still remained to be accomplished and about which, distrusting his abilities, if not some of his inclinations, he discerns no less misery in himself than real

passion for work. Let us add "the foundation of grief and melancholy" of which he speaks in the first of his letters; and place the painter in the conditions of his existence and of his work: he is poor, no dealer; no support by comradeship or school; two children to educate and soon a third one; the weariness of an admirable wife who, in order to preserve the independence of the painter, spends the best part of her time giving piano lessons. It is therefore in one of the most grievous hours of his life, the most decisive ones that Rouault turned towards Suarès.

Evidently, it took Suarès some time to open his heart towards Rouault. But he is not blind; listen to him: "There is," he says, "a deep contradiction within you. You search for your unity. I think you do not, at present, do what you are born to do. That is where your doubts and anguish spring from. The spirit of negation persecutes you." (19.12.1911). And this, though more general, is not less to the point: "It is better to lose oneself by one's own talents than to save oneself by those of others. But sometimes an artist is divided between two nearly equal forces, of which one is his doom and the other his salvation. Moreover one has to go where one finds one's happiness. For all and each one every step, the point is to listen to God's voice which is in us." Fine lesson, nearly perfect and Rouault applauds it. And it is Rouault himself who is going to complete it: "But if God gives us *inner humility* we are saved, and: the greatest evil, the end of the world, is to be afraid of loving." Suarès advises him, comforts him, informs him and sometimes reprimands him but always urges him towards the best of himself. Is it not after all a strange presentiment which makes him write in 1922: "I wish that without dissuading you from painting characters where you have such a strong and firm style, that you should increasingly seek in your painting of landscapes its transparency and the luminous clarity. To my mind you could succeed in what has not been achieved for a very long time: the religious landscape. Corot is a delightful pagan, the Watteau of his century. Cézanne is the great Christian, the martyr of painting. But the mystic landscape, not one painter has succeeded in creating for centuries, not since Rembrandt."

Their agreement is complete and Rouault well knows, what he owes to his friend. And that token of gratitude, the most beautiful he is able to render, the most intimate given indirectly: "A man who was not a painter took me by the hand fraternally and without preaching, without trying to play the apostle, *not blaming* but acknowledging in all my past efforts the profound sincerity of an artist in love with his art, he knew how to take me *just as I was* and to bend towards my natural inclination where my heart and mind tended to . . . all while I was *rebelling and striking out* against nature." (12.2.1914.)

We have been following a friendship from its birth to its fruition. It has been achieved: the painter's development has come about and nothing will now thwart it. Thus, when the old painter in his magnificent mystic landscapes was gaining complete self-expression and satisfaction, the man will, at last, have found the joy he was hoping for. Rouault had definitely found himself and made his choice; he no longer needed advice. There remained the gracious charm of the friendship. The gratitude of the one for the help received and of the other the gratification to have supplied it. And always through this long correspondence two minds were serving and extolling the same cult. With Rouault there was such a fierce and tenacious effort at the same time as such a profound humility towards his art, that finally all anecdote is blotted out in front of this powerful figure and the tone of his letters is occasionally reminiscent of that of Van Gogh.

Marcel Arland.

LETTER 1

> Musée Gustave-Moreau,
> 14, Rue La Rochefoucauld,
> Paris.
> 16.7.1911.

Sir,

My friend M. Letellier, 17 rue Louis David, told me of the possibility of my dining at his home with you one day; now it seems that he definitely left Paris nearly a year ago It is not, believe me sir, vain curiosity which drives me, because I have read enough of your splendid essays which have made me know you better, appreciate and even love you, and I do not have to see you for that reason.

I am at present reading *Crime & Punishment* by Dostoyevsky with great reverence. Yes, in spite of my failings I feel and discover at every moment new beauties, and what beauties, unknown and wonderful . . . in the midst of the most tragic and sordid realities transfigured by the genius

The joy of Christopher Columbus when sighting the New World, such is my joy. I have in me a fund of infinite sorrow and melancholy which life has exacerbated and which my art as a painter, God willing, will express and develop however imperfectly. M. Ingres is too robust and by a somewhat forced impulse and childlike christian feeling, I wanted to love him. I am punished for this. Since reading Dostojevsky I cannot re-read my little *M. Ingres** anymore . . . I wrote it in a flush of enthusiasm because of the strength, the skill and the willpower of the man and because of my irritation with his southern fellow countryman Lapauze who agitates himself in vain by saying: "Our young people will understand which lesson etc."

Please believe sir, in my profound feeling for art and in the sincerity of,

> Georges Rouault.

*Notes on Ingres which Rouault attached to this first letter. A. Suarès had just published an article on Ingres in the *Grande Revue*.

LETTER 2

To: André Suarès
 20, Rue Cassette, Paris.
 (please forward)
 Villa des Roches,
 Le Louldu par Aumperle (Finistère).
 Paris 22.8.1911.

Let me confess, your letter gave me great pleasure and I
would be glad if you would kindly let me know when I could
come to see you after your return to Paris without disturbing
you too much . . . I am rarely free during the day . . . but in
the evening after dinner I feel a great need to relax from time
to time
Life is an overwhelmingly powerful and strong experience
provided that one can extract from it the creative energy which
expands the mind and heart . . . I have started out on this path
and cannot now go back I had to depend on *myself* alone
and sometimes I ask myself, 'why is there so much effort, so
much resistance and sacrifice around me?'
If I cannot understand you intellectually as you deserve to be
understood, I can however tell you something which touched
me particularly . . . at a time when so much is supposed to be
done for artists (they will soon be pensioned off like labourers
or peasants) at a time which swarms with would-be artists . . .
you are probably the only person capable of allocating the
legitimate place to which the true artist is entitled and capable
of bestowing the royal favour . . . which they deserve if they are
worthy of the name of artist . . . a title so often prostituted.
I am, M. Suarès, in complete agreement with you in matters
of art. Cordially yours,

 Georges Rouault.

P.S. We may not agree on certain points or we may vary
slightly in our judgement of an artist, but I could see from your
numerous articles what joy it would be for me to be able to talk
to you from time to time I have a shocking fault which

has harmed me terribly, but which also made me a few very close friends. I have always said everything I thought and the way I thought it. When I was a small child, a face or landscape aroused a whole world in me I could not stop myself from dreaming of it or living through its memory I have continued to be the same child by trying with my own resources, clumsy if you like, to express my emotion.

After Gustave Moreau's death, my uncompromising art and insistence on frankness condemned me to the most atrocious misery. At that time I had numerous offers. I could have embarked on a certain lucrative series . . . but getting inspiration from schools now vanished and made with Gustave Moreau's patrons a retrospective art liked and profitable . I was freed from this slavery which I would never have agreed to by becoming curator of the museum. My needs being very simple, the frcs 2,400 appointment enables me to create and approach art in my own way I have two children but my wife entirely agrees with my point of view.

LETTER 3

16/12/1911.

Dear M. Suarès.

I must tell you how touched I was by your welcome. I really do not dare to ask you to come with me to look at my exhibition; I feel so much in communion with you and afraid to become less so (afterwards). I felt disheartened about my paintings when I hung them last Saturday, I feel more embarrassed than I would if I were to stand naked to the public gaze, they expose my innermost secrets, my purest feelings

If you would like to come to the museum on Monday, we will see Gustave Moreau's paintings and if you still wish to see my exhibition, we could then go to it together. I am there from 2 till 5.

In order to relax I am bringing my writings of many years up to date. Alas what you say about the tools one forges oneself , I know this well, but then how far am I from the goal? . . . Since

B

the death of Gustave Moreau I started writing, not from real intellectual need, but in order to relieve my heart; those are ridiculous and childish things, but I nevertheless read them with joy, they are old torments which have left me . . . only in order to get hold of me . . . in a different shape

Please come whenever you can. I am in the museum every Monday, but it is the last week of my exhibition. As happy as I am in front of Gustave Moreau's works, as troubled I am with what I have produced, well aware that: people will like or will reject it . . . and that I am unable to do anything about it.

Very affectionately,

Georges Rouault

LETTER 4

19/12/1911

I believe in your affection dear M. Rouault and I would like to reciprocate it. I sense in your words everything you do not say: but your heart is in it. How could I not be touched by that, I who search everywhere for life and extract it even out of stones. You give me the greatest proof of your affection which is your confidence in me, even to the extent of confession. I saw in your eyes an appeal to which I must respond. In order to reply frankly, I must take it upon myself to talk to you quite openly. I do not want to do this without having seen you in your studio amongst all your paintings, the most recent of them and the oldest. There is a profound contradiction in your nature. You search for your wholeness. I do not think that at present you are doing what you are destined to do. Your doubts and torments spring from there. Your negative attitude is your undoing.

I have a horror of giving any kind of advice to an artist: in art there is no advice to be given: there are only examples. It is better to lose one's way through the pursuit of one's own ideas than to attempt to be saved by pursuing the ideas of others.

It so happens that an artist is torn between two practically equal forces, one of which leads him to destruction and the other to his salvation. One must follow the path which gives one joy. For all and sundry at all stages, it is necessary to listen to God's voice which is within us and which is sometimes so terrifying for our kind that we pretend to stifle it.

I hope to be free in a few day's time; and then we shall make an appointment.

Good-bye, dear M. Rouault, best wishes.

André Suarès.

LETTER 5

Paris 28.12.1911.

Dear M. Suarès,
You have understood me and you have the gift of expressing every subtlety, which is rare, and you do not attempt to give advice which is even more rare. You say that one has to follow the path that gives one joy. I am 40 and really should have the resources to find my joy, but have never been able to achieve it, I mean to produce ceramics, paintings on glass and even painting as I would have wished, I am not referring to mental or internal struggles, but simply to technique and materials Péladon reproached me for wanting to give shape to my nightmares and for my bad humour I will stop now, it will be better for us to talk to each other about this, I hesitate, because I am afraid to talk (and to compel you to read) too much about myself.

In all arts if one delves a little deeper, one is bound to be confronted by nearly identical difficulties, by laws which are general, but notwithstanding very specific and well-defined by each kind of art.

My wife is a musician: when I married I perceived that her gifts were adapted to classical music Even if only in a

slight way, if we tend to develop our real gifts, we become necessarily isolated You thought so very rightly: 'It is better to lose one's way through the pursuit of one's own ideas than to attempt to be saved by pursuing the ideas of others' I feel completely an ever increasing communion with you; I could not say that of many painters! In our isolation if we are imaginative we have to beware lest we take our dreams for realities and regard our efforts as the world's axis . . . but if God gives us inner humility we are saved, because God's language and His spirit saves those who sincerely retire within themselves in accordance with what gifts they have I have always asked too much of people, that is my failing

I found in certain people a disarming goodwill which equalled their incomprehension

Since you treat me in such a brotherly way, this is what I intend to do unless you advise to the contrary: Do not put yourself out for me yet . . . I am about to make a fair copy of about 20 pages . . . from which you will be able to see me just as I am. These are notes taken over 10 years as compact as possible, some of them such as the landscapes do not displease me too much, and others which try to be ironical seem to me frankly bad . . . this irony and sarcasm would be better ended in a sob. Life may perhaps be my redemption, but I detest it . . at certain times it wounds me, distresses me

Good-bye dear M. Suarès, let me see you soon.

Yours gratefully,

Georges Rouault.

As soon as you have read the pages that I am shortly going to send you I would be very glad if you were to come to see my paintings as you so kindly offered; after the beginning of January.

My *Child Jesus among the Doctors* will be back in the museum, I have the paintings and ceramics of my exhibition already here in rue Blanche

I have already been to the Chinese exhibition at Durant — Ruel. If you have not seen it already I think it would interest you (until Saturday). My God. What a mess we are in: some

imagined myself to be strong but here I am cast down and crushed. Never did I discuss my feelings for art with my father . . . he never talked about it and I have a strong feeling that he never understood what I was doing . . . but such hidden and tender threads between us have just broken. This poor man without education as people say, had such humility, such gentleness, such kindness in his last moments that I cannot find words to say what I felt.

I had the impression that I was discovering a wonderful work of art unknown and not understood. This silent man and, simple all his life, even uncommunicative, opened up at the moment of death; he was like a child

I find the sympathy of people, in general, exasperating. If we are at all perceptive, we cannot but feel that we worry other people with our worries and torments.

I have a horrible sensation inside me that as soon as I throw myself back into art I reduce my family to tears and suffering and I know that if I satisfy my conscience as an artist others will have to pay for my joys I have a strong feeling (excuse my boldness) that I have found a brother in art . . . it has nothing to do with either your gifts or mine . . . I may never bring to fruition all that I have in me as you have done so completely: it is a question of the nature of your intellect. I shall never have your gifts, nor your culture, nor your judgement, not your finess, but I love my art as much as I ever loved my father . . . and without wanting to appear conceited, I see fewer and fewer artists who love their art very profoundly and this produces in me as profound a sadness as that which I experienced on seeing death in the eyes of my father.

Good-bye for the moment, dear Mr Suarès, please believe in my affection.

Georges Rouault.

Just when I was going to send off my letter, I received yours I was very touched by your letter. Yes, certainly, in spite of the reservation I previously made concerning communion with my father in art, there was (how mysterious all this is) another still higher communion . . . a worker in the holy craft which is art as you say so rightly An old craftsman like

my father was troubled and said quite seriously when he saw my mother or my aunts open a drawer brusquely and force it back into its place: "Oh these women! They do not realize that 'they make the wood suffer'." That may sound ridiculous to some people, but not to me.

My father was a man of few words and when I say in my assessment of him "he did not talk about it and I have the strong feeling that he never understood what I was doing", my judgement is blind and unsound. What do we really know of what is going on in the head or in the heart of the simple who express themselves neither in theories nor in eloquent dissertations?

I am completely isolated here . . . and it would do me good mentally to get out of my shell, because whether I make ceramics, paintings or enamels, I will never be satisfied with an easy approach to my profession: when I am 45 . . . or perhaps even later, then will my technical success approximate to my internal desire and to my need I dream (I do nothing but dream night and day) of recording my life . . . that would be a relaxation and perhaps a support, because I never wanted to see the road which I have travelled but only the one I would like to travel . . . sometimes I am overcome by an overwhelming fatigue and it is at those moments that relaxation would be good and even salutary. I have an imagination which plays tricks on me and the material side of the profession exasperates me sometimes . . . for such research, to obtain such results I needed months . . . because I depend on others . . . the paint merchant, etc. One has a certain thing in one's mind and one trips not because of their lack of will, but what is worse, an almost entire lack of comprehension, their routine has to be considered and things have to be done in their way. No one will succeed in getting them to change their minds. It took me nearly 30 days of correspondence and explanation to get certain paints and to be able to make certain experiments . . . but I have the firm hope that I shall win through in the end if I do not succumb to the pain

Very affectionately, once more.

Georges Rouault.

LETTER 14

> 20, rue Cassette Paris.
> forwarded:
> 'Ker Roc'h' Le Froudin en Plousecat
> (Finistère)
>
> Versailles 29.8.1912

Dear M. Suarès,
I have a son. I was anxious to let you know. My wife is well and everything went splendidly. I think of you with affection and look forward to October; please excuse my unaccustomed brevity, but just now I have not a moment's respite. Young Michael is already 10 days old.

I confess to my shame that I have not yet finished your beautiful book. I am as far as Baudelaire* which I read and re-read with immense pleasure; so there are still people on this earth with that magnificent, I was going to say charity of spirit, but I say more simply clearsightedness and fine intellectual lucidity; it has done me a great deal of good and has given me the strength to make my little effort.

I am not a very great artist, but I sense, I feel what a very great artist is and when one sees the mass of fools judging and weighing according to their judgement, with no discernment, one has to rectify these things.

In the realm of painters it is Fromentin who will be judged by Rembrandt who, you will see, will not interest him.**

Yours,

Georges Rouault.

*Baudelaire, chapter XIX of *Sur la Vie* published by Emile-Paul.
**Allusion to the Judgement of Fromentin on Rembrandt which revolted Rouault. *Old Masters* by Eugène Fromentin.

'Ker Roc'h.
Le Froudin en Plousecat
(Finistère).

1st September 1912.

May little Michael be happy. And above all healthy. And may he be endowed with the love of beauty and the faith to serve it.

May he also not give his mother too many sleepless nights.

I shall no doubt be in Paris next week, after having had fifty-three days of rain in Brittany: because we have already reached the forty-fifth. The fishermen and the peasants are ruined. In the countryside distress is general. This summer has made more widows on the sea coast than the darkest winter. Such a disastrous season is unknown within living memory. My poor Bretons have only their resignation left to face so much pain.

Why do you talk to me about Fromentin? The opinion of a mediocre man about a genius is of no importance: it is no concern of his. It is a kind of blind man's buff: the critic has his eyes bandaged: he thinks he can touch Rembrandt and he only touched a phantom, the little perception he has of him. Ultimately, it is only ourselves we reveal. Our critics only talk about themselves and their own kind.

Surely you do not think that Rembrandt bothers himself with Fromentin in the sphere of painters! To do him justice he is an honest man who did the best he could. Poison and spite flourish more these days.

I would like to cure you of this negative outlook, my dear Rouault. You should try to live for yourself and for your ideal rather than pit yourself against others. Time spent denying

and fighting is time lost. It is quite enough to know that our enemies exist. I would like to rid your painting of contradiction. It is the contradiction which shackles your gifts as an artist.

Good-bye, my dear Rouault. My wife is sending yours her affectionate greetings although she does not know her.

André Suarès.

LETTER 16

Versailles 8/10/1912.

First of all thank you for your letter. You are right, my dear Suarès, I am not Rembrandt, but even a Rouault has other things to do than to allow himself to be spellbound by Fromentin; my obsession is to dwell too much in the past, that is the result of Gustave Moreau's conversation about his friend Fromentin. I think I am right in finding fault in the name of Rembrandt and of Gustave Moreau, but I know, hang it! that I am no judge.

My vice is to work too much, something which will seem to you exaggerated, but no! Believe me, Gustave Moreau had reproached me for it already. He said in contrast to many of your colleagues you work day and night, at least your mind and your imagination do, and the hand obeys afterwards. First this horrible place, these cold streets, these gloomy mansions have chilled my heart, then again the death of my father, the birth of that child has not smoothed my brow and the daily constant worries make things even worse At the risk of being too bold, may I say that I would be very happy if Mme Suarès would get to know my wife. I am practically certain — I say certain . . . that my wife's simplicity, sacrifices and silent acceptance will touch her. Mme Letellier was a dear friend of Marthe, we miss her every day.

As for me, I am resigned and I compile extensive sketchbooks at the same time as making research into

ceramics, which warms me a little to my surroundings and to all that I see, but the first sketchbook will be a cry at once more bitter and more painful. Certain landscapes give me a feeling of relaxation and I hope that in six months time I shall have accomplished something.

I hope to see you soon. Affectionately yours,

Georges Rouault.

LETTER 17

15/12/1912

Shall I see you soon, my dear Rouault? You know that I am always at home.

We will make an appointment to go and visit Cézanne. He is more slandered today by those who copy him than he ever was by those who insulted him. That is the law. Everyone can only make his own salvation and will never that of others. How spiritual Cézanne is, he is a shepherd of art who never tired of reaching out towards the stars.

Adieu, my dear Rouault, and sincerely yours

André Suarès.

LETTER 18

Versailles
16/12/1912

. . . I am anxious to see you soon, M. Vollard hesitated to invite you to dine with me at his home on Monday, we shall talk about that again shortly. I have a large sketch book (130 items, of which 50 are popular songs with coloured

lithographs), that devil of a man told me when I went to see him: "Have you become a travelling salesman in lace?" And taking the sketchbook out of my hands he pretended to be keen to see it, "Formerly," he said, "I would have been delighted to publish that . . . but I do not publish anything any more." . . . Best wishes, I greatly regret seeing you rarely.

Affectionately

Georges Rouault.

LETTER 20

31/12/1912(?)
Hyères, Villa Hubert

What did I tell you my dear Rouault? Your nightmare is over. The new year will lead you to light and serenity and to freedom through a vision pacified. Our life is a struggle as the Church knows only too well. As soon as we begin to apprehend we have first to fall into a Hell of darkness; this is the first test. Then we must bear its all embracing terrible anguish. Most people remain in that state. They even finish by getting accustomed to it and by remaining in that abyss.

One has to climb out of it and raise oneself in order to reach the beatic vision which is the form of one's own creation, thus making a divine choice. This will replace the original nightmare.

May you be endowed with this clarity, my dear Rouault. I wish you all prosperity at home, so that you may find the freedom of spirit, which is a 1000 times more necessary to us than all other freedoms.

One could work at a masterpiece in a cell. But surely one would not be able to work amidst the misery of one's nearest and dearest or amidst domestic anxieties.

My blessings, and health be with you all. Rest assured of my affection.

André Suarès.

My wife sends her best wishes to Mme Rouault. She embraces her together with your children. She is greatly touched when thinking of little Geneviève. It is having a little Geneviève and a little Michael of her own which she craves so much, more so every day.

LETTER 21

(about 1912)

Dear M. Suarès

Here I am in bed with a terrible headache: I only hope it is nothing more than neuralgia contracted in this cold and horrible part of the country I so detest; I await the 17th of this month with impatience, in order to add some pages to my sketchbook on Versailles, there will be some goings-on that day . . . to sketch.

We intend to sub-let our flat, perhaps next winter, which is often done here, provided it is not too difficult for my wife on account of her lessons

Since the death of my father I have worked too hard, I have two sketchbooks in the course of execution, I hope to finish one more on the statues and monuments of Paris next winter which could be very rewarding. I have 30 large lithographs and as many ceramics, all done in the midst of hostile surroundings — I mean Versailles, and without any encouragement, discussions or friendly conversations. Without meaning to be arrogant I find that my present research has cut me off from my old friends who still expect me to create the same kind of paintings as I did ten years ago.

When we go to Vollard should you be free in the afternoon, you could come to the museum to see my *Child Jesus among the Doctors* and some ceramics, I am anxious to have your

opinion. I was a painter of stained-glass from the age of 14 to 20, I think I could have become a good lithographer and potter. The medium itself is basically unimportant as long as I can express what I feel; the better it expresses my feelings the more gladly I will adopt it. We are surrounded by such ignorance that I have heard quite intelligent painters consider their canvases to be absurdly superior to the work of a dedicated potter, etcher or engraver and regard them as inferior craftsmen. Must the essence and the medium itself of a work of art be misunderstood? They make large paintings and consider themselves great painters and ignore the fact that the inspired craftsman who has love and the faculty to express himself must leave his mark on everything he touches. And then they do not recognize that there are mysterious 'laws', great hidden laws which one disobeys at one's peril. If the perceptive and sensitive artist who is completely able to convey his inspiration in an intimate or vivid way should aspire to create what they call *la grande peinture* for which he was not destined, he would lose the essence of his gift and inspiration though his pride may be satisfied

Please, let me know what you think about the visit to Vollard; you know that above all I would not want to thwart you in any way, but it would be advisable to have a sample of the lithographs before mentioning anything at all about the sketchbook

I will have to take back my sketchbook on Monday but can return it to you afterwards . . . as I have to go to Paris as soon as the price is settled, we could meet in order to visit Vollard. Madame Suarès would perhaps like to come and see the Cézannes, it would be easy to arrange if you so wish?

It has taken me a long time to write this letter, but having started it yesterday I am glad to be able to tell you today that my headache is better I talked to you a great deal about myself, I am lying on this bed and not doing any work, which is a blessing in my present condition, a well-needed rest. I am glad that I know you better and hope that in many ways we shall both feel the need of an even closer bond. Trust is such a tender thing, and if I am hostile to the world because of my nature, my dear Suarès, I dearly hope to enjoy the sincere friendship of some true artists as I think I did in the past, it is

the only kind I aspire to, but even should I lack it, I think I would still survive. However, it is good and pleasant to be able to relax from time to time. When I retired to Versailles I was still full of illusions about people in spite of having had a rough time since my childhood . . . and I confess that after being away from Paris for a year I felt a certain sadness. Now it is with a little disdainful irony tinged with pity (which probably would not be felt for me) that I can see my wealthy friends whose admiration and enthusiasm I previously enjoyed, turn away from me in rear, in case I should say: "We are dying of hunger" It amuses me to think that by simply speaking of my present situation I have frightened off some who were formerly enthusiastic; but miserable fools! Even if one day my children were to perish from starvation, never, never would I let them know . . . anyone who knows me however slightly would have no reason to doubt this — such things one confesses to a brother, a rare spiritual brother, to an exceptional being, capable of helping one to continue notwithstanding, but not to those who flaunt a conventional idealism and who in so doing expect to abase oneself and produce rubbish in order to live as they say.

Always yours and till Monday, I hope.

Georges Rouault

P.S. Kindly put a cross if the occasion arises on the engravings and songs which you find acceptable; I have also been advised to get myself a dictionary of rhymes, obviously I know nothing of your profession and must have made many blunders in my songs.

LETTER 23

February 8. 1913.

My dear Rouault,
 On Monday I hope to go to see your *Child Jesus* in the museum, I shall be there and I am counting on finding you

there. Should you not be coming to Paris, please let me know.

Anything that pulls you away from Versailles is good for you. Think it over. You are depressed there in that sad house. You must rid yourself of the canker within you and purge yourself at any cost of your deep depression. Why? Because that depression is only part of your personality. If you were 60 I would not be talking to you like this. I would not expect Forain to be frank or charitable, nor Huysman to have an innocent candour. We all have suffered miserably from the cruel and heartless city, in the midst of a universe which is so beautiful and deserves to be redeemed. It deserves it: because of our faith in it, and maybe because of its beauty.

It is enough to pass through it, we are certainly not intended to remain in hell.

We must first of all seek our own salvation, we can do it only by not rejecting suffering: that is the first stage. And the second is by raising ourselves above the darkness, the spite, atrocious despair which excess of suffering and the injustice of man has inflicted on us. One cannot live in a state of negation.

The greater the artist, the more he has to create beauty with the knowledge of the horror of evil. It is true that one has to have the courage to absorb this evil, and to have the strength to bear it. But not to free oneself from it is not to live. It is the artist who delivers mankind from pain, by giving it the most beautiful shapes by his love. Look at Rembrandt, that master of painting, a hundred thousand cubits above pagan plastic art.

The artist must deliver the world from pain even if he cannot deliver himself from his own suffering. Dwell on this thought.

You, Rouault, will not remain in a state of negation. It is a period in your life which was necessary — which still is legitimate and which you have to overcome.

C

Overcome it then; but prepare yourself for the coming dawn. Father Moreau was right to believe in you. He saw what you could become in the light of what you have been. That is also what I perceived myself as soon as I saw you, and that is what I expect from you. We are not alive unless we march in the light towards a continual renewal like nature itself.

You must not lock yourself away in your room in Versailles. You would betray your own originality. You are not one of those who need to cut themselves off; but on the contrary you are one who cannot dispense with the spring outside and the miraculous example which an eternal renewal of eternal beauty gives us. You do not lack the shadow nor the gravity of darkness; but you need the divine counsel which light gives to forms and the promise of love if not of happiness which it makes them.

I grasp your hand with affection.

André Suarès.

LETTER 24

Versailles 12/2/1913
Tuesday morning

. . . I am very glad that I shall be able to come and talk to you on Monday; I can discern the elements which can expand or contract my brain or my heart if I take the trouble, but there, I do not always take the trouble, and then I seem distracted or without discernment. I try to blind myself, and my enthusiasm about people certainly does not last long, no! It does not; I often told my wife, "Look, how certain trials in life enlighten us about ourselves and others", which is common-place, but I wanted to say, that for certain natures like hers too unsuspecting and simple, nothing takes the place of facts, and I who act as tutor am usually deceived, though considering myself to be sharper, my experience profits me but little I cannot on account of conventional ideas put

blinkers on and block my ears, not see and not hear, not feel
any more, but I am alive . . . not yet a corpse . . . and above all
I have the misfortune or the joy to feel like a passionate and
proud artist. Well then, I am aware of my failing: despite my
sharp critical sense I still ask too much of men . . .

Good-bye affectionately,

Georges Rouault.

Who is going to write to you frequently while expecting to
leave the King's gardens without regret and Versailles joyously,
at once?

LETTER 25

3.3.1913

Please accept my sketches which I am sending by my friend.
You can hand over to him the books you have finished in all
confidence. I regret that I am unable to come myself.

Please tell him whether I could call next Monday to fetch
them after you have revised them; I shall go over them with
China ink then the pencil drawings with soft bread; I shall stop
at Vollard's at the same time the Monday after at 10 o'clock in
the morning, I hardly dare insist pointing out to you that in
accepting his invitation to luncheon you will have a greater
opportunity of influencing him; the menu is not very varied
but it is excellent: *riz à la créole*, usually with pigeon or light
meat and vegetables. It would be better to see him first in case
he should put you off your food. (I don't really think he will)
and then you will do what you like about the invitation

In short, my dear Suarès, you will have noticed that having
been weighed down by my abortive efforts I righted myself
again when you spoke the right word to me, because those who
regard themselves as right are complacent . . . they proclaim
and dictate laws to poor devils for whom they feel pity (a
supercilious compassion, protective rather than charitable)
when they are searching for their soul through their suffering.

You ought to go one day to D.; you would see that I have not been asleep from 1897 to 1912 — Father Moreau reproached me for not sleeping enough, for being too wide awake night and day, (without wanting to boast there are not many to whom he made such a reproach).

Yes! I have been awake since his death, I have continued to be so and not, I think, to excess. I know my limitations better than to be tempted to go much beyond them. It does not worry me, but I know the domain where I must live as far as we are able to know anything. One has to pay for everything . . . and for ten years I refused all distraction, all external pleasures (or what the world calls pleasure), journeys to Holland, the Flanders, to Italy graciously offered, but where I would have felt no communion with the people involved, I have that other joy: that is, I am alone . . . I know that I breathe pure air, and that my suffering will soon be transformed into creative joy, in spite of difficulties which more than once I thought would crush me.

During these last fifteen years many of my colleagues have become established and settled, I seem merely to have strayed . To know yourself, not by discussion, analysis and verbage, but to know yourself through suffering and in suffering, to know yourself through living and in living, far from snobbery and the contrived, but through seeking the truth with the effort of our whole being.

To measure oneself, to know how to stretch and also how to relax, to be master of one's imagination, of one's nerves, of the excitement of one's blood, one's mad rages and one's holy anger on account of the Injustice which rules the world, or at other times to let them go, let them go without apprehension and without fear knowing that at an instant, one will be able to master them, that is the apprenticeship of life and art that springs from it will not be castrated.

A bientôt et croyez à mon affection.

Georges Rouault.

LETTER 27

Versailles 14.3.1913.

It is all settled, I have Vollard's reply; first we call at his gallery and afterwards go to his apartment; he seems delighted by your acceptance of his invitation, this will give us more time to see the painting, he says. I shall let them know at the museum that I shall be calling there, but this time in the late evening. As I did not want to take Vollard by surprise. I let him know that I would bring with me a portfolio with my tragic ballad (the one you kindly inspected and rectified) in order to take it to Floury afterwards. I talked to him of M. Doucet's visit at the same time saying that my landscape seemed to please him; he answered saying that he was not surprised to learn that you were interested in my research and that he was very impressed with my sketchbook; he added that unfortunately this was not in line with what I am doing.

We shall talk about this again on Monday, we could proceed as we did with Floury, give him the originals, and if the originals sell, the reproduction will follow.

Mme Suarès should not hesitate to come and see us one day, and must not think that she would disturb us; my wife is much less busy this month on account of the Easter holidays, and we would be glad if the children could thank her personally.

Hoping to see you on Monday at about 10 a.m.

Georges Rouault.

I will call for you at Rue Cassette.

LETTER 28

Versailles 14/4/1913

My dear Suarès,
 I am anxious to let you know that M.D. just took five of my

drawings (landscapes) and an engraving. It is you I have to thank for this, but I cannot do it personally and am anxious to let you know as soon as possible. What can I do in exchange for your kindness on my behalf? I read the Songes* and noticed that I knew it already. As you said so well, they are beautiful, sad dreams

You who have a good and gentle influence on the black melancholy to which I have been subjected and gradually helped me over it without interfering with my innermost nature, I find myself unable to be of any help to you, but am very devoted to you as you know, and cannot express it in words.

I still have Monday's music in my head, it has been with me all the week, you were most kind to let me come, as I would certainly not have disturbed you, knowing of the work you have to do and of your need for solitude. Have you good news from Mme Suarès?

<div style="text-align:center">Very affectionately yours,</div>

<div style="text-align:right">Georges Rouault.</div>

*Sur la vie, chapter III, Emile-Paul, 1912.

LETTER 30

<div style="text-align:right">Versailles 7/5/1913.
Tuesday evening.</div>

. . . Rouault's dream is to meet the need of his whole family by himself without surrendering . . . an atom of his ideas. It is as if a gleam guides me and I think that my wife has and will, in future, have enough talent to stay at home to give her lessons and even if I am wrong, I know that it is in Paris where I was born, that I belong. My mother was born in the rue Ste Croix de la Bretonnerie and her father came to Paris when he was 12 I can sense certain things . . . my ceramics need a great effort and some money, and my paintings long-drawn research. I have the knowledge to make engravings to help me,

and I am a miserable fool if I do not succeed.

I hope to have news from you soon.

Yours,

Georges Rouault.

LETTER 32

Versailles 11.6.1913
20 rue Cassette Paris
forwarded to La Mattiniere
St Malo la Lande (Manche)

My dear Suarès,

I came to thank you for your two books and for your dedication of one of them; you appreciate me for what I am usually disliked for, which makes me very happy.

. . . I am completing, pasting and repasting like a good framer 50 to 60 drawings for engravings. You know that the publisher Floury wanted to have them or at least the sketchbook. This is the idea I have had and which I submit to you.

First an exhibition then in a year or two return to Paris (especially if I am sure to be able to send my children away during July and August).

You were saying that your books do not bring you in anything (or very little), which I suspected; could we not come to an arrangement with Floury or someone else and instead of making this sketchbook myself which will eventually be published without my attending to it too much, could we not perhaps try something: either religious plates as you will see them from my embossed drawings or landscapes with a grave or tender note with certain texts from you. You have enough imagination to make my contribution clear. I will agree as in the golden times of the cathedrals to adorn with devotion your monument to Dostoyevsky or to Pascal and . . . if it is unsuitable I will agree to withdraw from the project. One or two plates will be sufficient to settle the matter. In a month or two from

now my 60 plates will be ready of which you have already seen about 20 and you will then be able to see what use you can make of me; 5 or 6 plates will be enough, perfectly reproduced and luxuriously edited as was done for Claudel in *L'Occident* or in any way which suits you.

Sunday or Monday (15th or 16th), exhibition rue de la Ville L'Évêque — a dozen Grèco, Corot, Daumier, etc (collection Marayette Nemes). I have four important paintings in this collection, but they exhibit old masters only for the moment and Degas.

. . . You were talking recently of notes by Gauguin and of commentaries by Ch. Morice.

Perhaps something of that sort would be needed, but the commentaries should also be in the same style as the notes. Ask Suarès to collaborate for a more important work of which you have all the important parts; but you know I dare not. Why am I so inhibited and why do I not go straight to the point? It is because I have suffered too much and I have lost the urge for action. I can see infinite possibilities and preferring to act after reflection I make myself think too much, so that I do not act any more, and not being a person fundamentally lacking in confidence, not very humble, I vacillate between an excess of humility and an excess of pride — but with you I regain my natural simplicity.

<div style="text-align:center">Very affectionately</div>

<div style="text-align:right">Georges Rouault.</div>

Had you had no artistic interest in what I am, and in what I am doing, I would not have confided in you as I did; those who think of me as boundlessly proud would never, I repeat, never know about the terror of birthpangs of a man isolated from the world: it is when he manages to give everything he can, and must give that he blinds himself most, that he tortures himself in order to achieve something better which he may never attain; quite often at the moment when he gives the best of himself he is unaware of it. For hard work is experience at certain times: the fatigue of the eye and of the mind. Nobody will ever be his own judge, despite masters, critics, and people of good sense and reason. The unconscious has a part in

creation which is not just an effort of the will, nor is it wholly unconscious, nor is it pure chance, but it is something indefinable, fleeting and profound nevertheless, which to a certain degree for certain reasons makes a work of art either alive or dead

. . . My wife has just received a letter from Mme Letellier who would like us to go and stay with them for a month together with our children.

LETTER 33

Versailles
25.6.1913

My dear Suarès, let us continue our conversation interrupted as it was by my departure, and also by my desire to leave you to your work, if I had been free I am aware of the skill that I possess, I am aware of the fact that it can achieve things which are rare, great and powerful. I am aware of the poor results that some have achieved by work and not talent. I know that there will always be a barrier for them, precisely because they assimilate other people's ideas which is fundamental to their nature, of this I am aware, well! And then there is the daily struggle during the last 20 years: increasing loneliness and in Versailles, which means on the North Pole of art, never an intellectual communication at the opportune moment; though I do have a devoted friend (Jacques Maritain), but he is weighed down more than I am under the burden of interminable and daily work. Well do I know, as I have just said, well do I know what I have to do and I do it, but as a result of years of exertion at the very moment when perhaps I am reaching the goal, I am overcome by an immense weariness (which is not the same as discouragement) and thereupon I cease to listen to myself. During those hours of weariness the slightest suggestion, the slightest thing however mild it may appear, takes on catastrophic proportions. I no longer know nor can see the reality of my efforts, but like a fool only the realities which go on around me. Even though I know

that I have to carry my burden ten more steps in order to reach may be a very formidable stage of my art; and I stop in order to reply to the babblers, the theorists, the inquisitive and clever people around me: a waste of time, to be sure, what one might call preaching in the desert, the desert of Man which is Life for me

I know what you told me about the dead Christ and I agree with you, I am keeping the cartoon in the museums I am satisfied, the effort that has gone into landscape and religion, big ceramics and also landscapes will fortunately counterbalance the satirical and the grotesque; only I must proceed in an orderly fashion, on no account must I allow myself to be distracted before I have finished my work and produced 140 engravings of which 40 are important and others, smaller ones, though some of those have just as great an artistic interest. I have just made an assessment: the landscape (and the religious) part will be more important, but the connection with the satirical aspect will not feature this time, yet it could be done in certain works, but it is important that my exhibition should not consist of study material only.

Georges Rouault.

LETTER 34

29 June 1913

Consider yourself in the right as long as it pleases you if you can draw strength from it, my dear Rouault, but at least stop regarding others to be wrong, this struggle leads to nothing.

You have come to recognize your true nature. That and the fruits of ten years work will be your reward.

You have studied the masters. You have followed them; and you have understood their important message: it is to be oneself. A lesson in vain in most cases, because it is given to few to understand it. To be oneself is granted only to very few

people. Sincerity is nought, if one has nothing to say or nothing but vulgarities. Anyway, one approaches the masters more closely by making one's own mistakes instead of not making their's.

You have been searching for yourself. And it seems to me that you will find yourself. You have courageously thrown yourself into analyzing your feelings. You have seen this world too much through your own feelings of revolt and anger. But these feelings were inside you and you had to rid yourself of them. The hour of deliverance has struck. It is nature, the great liberator which will bring it about. Henceforth, live in harmony with nature.

You stepped out of the suburbs, from the cave, and from places which are peopled by monsters. You must keep away from them forthwith. You are too good for this sinister Hell. It is enough to have passed through it and to have gone through the trial of black fire and its horrible smoke. But you needed to go through it. One cannot grow in the shadow of Rembrandt. Under the tree of Paradise any shoot perishes.

All your effort has been justified, because all of it was sincere. In my opinion only you could profit from Cézanne. I think you have a technique of painting much more fundamental and more rigorous than your rivals, because it is personal to you. Instead of endeavouring to please by every means, you have desperately tried rather to displease. Do not attempt now to do either: raise yourself thus above the public and the schools. Regarding the teaching of the good and noble Moreau, you alone have penetrated to the marrow; you have only extracted its nourishment, because you were the only one who neither cleverly copied Moreau nor the Masters. You are too genuine to be clever. But you have the love of the material and know how to handle it. You have within you the taste and the instinct of rare material. You must now direct all your gifts and put all the elements of your talents in order. But there is no order without hierarchy and not everything is on the same plane.

I entreat you therefore, once and for all, to put aside all negation and to chase away harsh criticism which a hard life and social injustice have brought out in you.

To an artist, criticism is negation. We are artists to affirm, that is to say to create something beautiful. We have to live in order to be really ourselves and for what we make and not for what others cannot make, for what they are not and can never be. For we are surrounded by phantoms and spectres: the number of people who do not exist in art is immense. Our mission is to be and not to deny. Those who do not exist as artists, deny their existence themselves. Your preoccupation with them only gives them reality. And they appear to exist only at our expense.

Do not be in a hurry. Proceed methodically from engravings to ceramics, and from great fired pots to painting. Take your time and be in full possession of yourself. You will rid yourself of our past by mastering it. All art which is more complete and freer claims you.

How right you are to count on me. I will never impose my will on you, not even to divert you from your black despair which irritates me. But I will guide you, I hope, towards the highest regions of your art and to the most durable parts of your own nature

Everything that does not have a great human foundation, eliminates itself; this does not require much time.

A powerful truth in art carries within it an idealistic and serene view of objects as well as of feelings.

I am awaiting the time when you will take to your religious cartoons once more, and paint pictures embodying everything which ten years of effort, research, suffering and harsh discussions must have taught you. Cézanne went through all this. You are no longer the wise Moreau's best pupil, nor the most gifted of the Amsterdam School: you have lived your life and you are a painter.

Good-bye, my dear Rouault. Do not come tomorrow. I will not be free, except in the evening after dinner about 9 o'clock.

<div align="center">Affectionately yours,</div>

<div align="right">André Suarès.</div>

LETTER 35

<div align="right">2/7/1913</div>

Now you have the proof, my dear Rouault: I anticipate your feelings and your own discoveries about yourself. I answered your letter two days before receiving it.

Nothing reassures me more that I am not deluding myself regarding the course you are taking: it follows the very path that I recognized for you, only even more so. My only merit is to perceive in your character and to read in your nature that which escapes you, because it is not set out in front of you. In the end it is my affection which guides me.

You move with more and more assurance in the direction of your own truth, and deliverance: it is near at hand. This is what I hope for with conviction.

<div align="center">Always yours,</div>

<div align="right">André Suarès.</div>

LETTER 36

<div align="right">Versailles
4/7/1913</div>

. . . From excesses of my imagination I proceeded to excesses

of realism (engravings etc.), which one would not have expected to be in my nature, I am going to do what in my opinion is the most difficult thing: to put things in order.

You talk to me of hierarchy, I can almost hear you, but you tell me also that I am a painter and that I have lived my life to the full; moreover, though the dark side of my nature irritates you, you accept it and do not mind my being as I am . . .

Here then is the hierarchy, at least as I understand it:

1) Ceramics, because of the materials.

2) Paintings, because of some undefinable thing, relating also to the material and to the agony, and the ease with which one can alter them . . . to the sweat of the labourer over his work and perhaps also, with the very important laws of composition allied to the rythms which I perceive in nature and which I have inside me and which is not my merit just as it is none for many others who paint direct from nature and excell in it, if born with this gift

Hence I only work through these two mediums (ceramics and painting) but it would be good for my perception and my craft to endeavour to compare my engravings with them . . .

. . . It will be seen that the series of *Women* and *Girls* are summed up in a *Salomé* — but now I will have to proceed as smoothly as possible

Do not take what I say literally, as I am relaxing just now . . . such a *Salomé* and such a great *Christ in red* may induce me to make another engraving on account of shapes seen in real life, the plastic language being so powerful . . .

If it seems that I have erred a long time it is partly because of shapes, figures, feelings, emotions accumulated inside me formed an insuperable obstacle which needed to be brought out in some way or other; on the day of deliverance there was an outcry from my friends, or least from those whom I thought to be my friends. After having put a label on the back of a poor chap he is forced to do what is expected of him: I have been a mystic and have given birth to a wild and demanding child that raised his fist to society from the moment of his birth, I have been for some of them a man who should look to Heaven

with raised eyes like St Augustin and Ste Monique d'Ary Scheffer I began to be delivered, little did their judgement matter

If only you knew (and you do know it) what so-called serious art has come to, the whole school and the academics have influenced even the spontaneous and charming art of engraving; it is when one talks most of popular art that one achieves it least

Thanks again, my dear Suarès for your letter, but you will instantly make me even more enemies and isolate me even more (all the better for the isolation) by saying that I am probably the only one to have understood Cézanne's lesson.

Gustave Moreau has displeased many of his pupils by saying that I was living in perfect conditions of simplicity and isolation and by adding that this is how an artist worthy of the name should live

Your acclaim alarms me particularly when I compare it to the little acclaim I am generally accorded.

How vast is that solitude and what a prison!

What danger to think of oneself as being in the right, to stand erect or to be discouraged and to abdicate! But also what wisdom one acquires sometimes when one finds oneself in the whirlwind once more

<div style="text-align:center">Very affectionately</div>

<div style="text-align:right">Georges Rouault</div>

LETTER 40

<div style="text-align:right">30/8/1913</div>

Next Monday at about 5.30, impossible tonight, even after dinner, I am busy the whole evening. Thank you for your message. Next Monday my dear Suarès, I think I shall be able to give you some news, I think my exhibition will show landscapes allied to religious compositions, but the composition will derive more directly from Nature than in the dead Christ.

Example: the other evening at about 8 o'clock before dining
I went for half an hour into the park,* in wonderful weather
which I had not seen for three months Next day I went
over the series of landscapes again completely, the same ones
of which you have a few; the vision unwittingly becomes more
serene the more I discover (without wanting to) the points
where X Y and Z burn their fingers** They will be on
different ground, what is in one's heart and mind cannot be
borrowed.

Bien vôtre,

Georges Rouault.

*The park of Versaille.
**Allusion to some imitator he had from this time onwards of whom he said
later on that they "sometimes lower his pictorial intentions."

LETTER 41

Versailles 2/9/1913.

Mon cher Suarès,
 . . . We have been through bad times, as I have already
intimated. My wife was very tired indeed, the two children had
an attack of enteritis, (very serious for Isabelle), today we have
to take infinite precautions; moreover I have my mother in bed
at present, and my wife is not any better either. The worries
and excess fatigue on account of the sick children made her
very nervy.
 In the midst of all this I am recovering the necessary
composure to revise my engravings, which shows you what
degree of selfishness I must possess
 All this retards me somewhat, but nevertheless I am making
a strenuous effort every day, the most difficult one being for
the engravings.

 180 engravings with a white surround to act as filet,
 180 on grey sheet to indicate a restful background, and
another 180 on white sheet as filet.

180 + 180 + 180 = 540 sheets which I had to trace, cut, dip, and stick the captions and the songs to write underneath.

Bien affectueusement à vous.

Georges Rouault.

LETTER 45

Versailles 28.10.1913.

My dear Suarès,
 Two words only just to tell you that I certainly blundered, dedicating a sketchbook to you before a more complete one of landscapes or one on religious themes was made. This one is too much of a farce, in short it only shows you my good intention and is the proof of my gratitude, I am sure that you will realize this.

Georges Rouault.

LETTER 46

Versailles 23.10.1913
Thursday.

Mr André Suarès
20, rue Cassette.

 . . . From now on ceramics will take second place. This is just what I have dreamt of! And nature itself, even in Versailles, will help to bring this to fruition! Landscapes (not as understood by the professional landscape painters) are my stepping-stones on which I shall re-establish myself.
 My dream nevertheless is to return to Paris after the exhibition, provided I can find somewhere where to take the children in August and September. I spend much more here,

especially if we take them to the country every year, (and the children were just as often ill here as they were in Paris and as far as I am concerned it would be useful to see other countries).

. . . My exhibition will probably be ready in six months time, hardly before . . . it will be much more important as far as painting is concerned than I had formerly realized!

Mme Suarès mentioned something to my wife about a foreword by you, is that possible? Can I also mention it to Vollard? As for myself you know what pleasure it would give me!

Did you know that Vollard's gallery will form the corner of Bld Haussmann once it has been broken through?

Georges Rouault.

LETTER 47

Versailles 30/10/1913

Mme Suarès should not take me for a 'Quaker', but

1) if I could be useful to that person and try to get him accepted at the *salon d'automne*, I would do so only after seeing his painting.

2) Well, and two years' subscription have not been paid . . . and I did not exhibit, and *in addition* have no strings to pull any more even if I have ever had any. Also I am not on the committee any more . . .

Concerning my wife's health I am distressed.

She nevertheless feels better than in the summer, but it is this thinness which worries me. She weighs herself every fortnight and finds that she has still lost weight, perhaps this diet does not agree with her, never any bread . . . I called for a second opinion, this time from a homoeopath.

Now she has good nights at least, it is three weeks since I withdrew her from the children: the children have tired her out by their demand for three months during the holidays, let us hope it is but that, but I confess I begin to be distressed.

I well realize that I am at a watershed at the moment, or rather on top of a mountain: on one side life, on the other the past, my past: it will come back that past; it has not died, but the dream of reconciliation of the two is humbug, I have felt this for a long time, actually I have always felt it: that is the cause of my malaise.

Granted, nature must do it; good advice must come from neither X nor Y nor Z, though I am reproached for shunning it from pride. Advice will have to come from nature itself. There now, we agree on that, don't we?

<div align="right">Georges Rouault.</div>

LETTER 48

<div align="right">Versaille
1.11.1913.</div>

. . . If I were sure that I was returning to Paris next year, I would finish the engravings (at least one and a half or two months' work) and then in six months' time I think I could bring the paintings and would keep next winter free for the ceramics, here (or) in Paris.

Well, we shall see, even if I have moved to Paris either next winter or in the autumn, I may make them here on condition that I can take a month's leave on account of my mental fatigue; if I am worried or anxious the struggle with my paintings as remedy is heroic therapy, but one which I cannot pursue indefinitely; besides the word 'struggle' is not quite right any more, it is rather a period of calm and reflection which I go through; even where my ceramics are concerned

The terrible side of my nature is that I am never satisfied

with myself, and do not entirely enjoy my successes, and constantly see and am aware of the progress which I must accomplish.

However, I am on the way to accomplishing this; at first I only plan to have an exhibition of ceramics and prints, but now it seems to me important that I include my paintings as well. At last I may have found a material which fulfills my needs, a material for oil painting which is neither shiny nor glittering like enamel, nor too matt as in frescoes but sober and deep.

You will see in the future how the experience in engraving has been of use to me even for grotesque paintings. I have acquired a style in painting which I owe to it and to ten years of research.

It is not so much a difference in light, but the inner need is simplified and becomes clear.

Bonnard was the only one (yet I hardly know him), at my first exhibition, at Druet, who was not greatly impressed by my ceramics, but was very much so by my paintings; he was right, I see it now.

This craft, which seems so difficult when one first embarks on it, will once again give me pleasure, it is made for me and now I will not strain any more but enjoy it a little.

I must confess that I now find painting much less difficult than my ceramics.*

Bien vôtre

Georges Rouault.

Would you kindly let me know on which evening I could make sketches of the cat, for an hour or two (a few drawings only) without disturbing you.

*He did not like the shapes of vases and dishes.

LETTER 49

Versailles 4.11.1913.

. . . Of course you can come to Versailles whenever you like, it will always give me pleasure, but as far as my painting and my ceramics are concerned, I shall not have anything to show you before six months' time.

The important thing is to achieve real progress. On Monday, after having glanced at certain paintings from my last exhibition I was more or less reassured.

I am on the right path, you will not regret your letter. I think that you have been a clairvoyant.

Georges Rouault.

LETTER 50

Hyères, Villa St Hubert
11.12.1913.

I wish you were here, my dear Rouault. You would have the illusion of antiquity. Light has created shapes. From Marseilles to Hyères we have Greece; and from Hyères to St Tropez, Sicily or Homer's Asia.

I am bathed in light and utterly penetrated by it. I have rediscovered light. It leads me to a state of ecstacy which may even be dreadful, where in my view nothing, absolutely nothing matters more than beauty: then one dreams relentlessly of liberating oneself from everything and who knows? Even from life itself.

If only I could draw you into this sky and into this atmosphere. At this time of the year there is no brutality or harshness any more: here is the refinement of the North as well as the immense heat of the classical countries. Everything is meaningful and the values sing with exquisite modulations.

I spoke to you about the country around Arles at Easter. Such days are not unique. I had forgotten about the weeks in St Martin at Xmas. Provence in December and in April was Cézanne's marvellous teacher. But what a disciple! Such love and such sensitivity.

Nature, in accordance with the intense requirements of the style imposes itself absolutely on the artist. Light gives birth to this need of the style.

Here you could no longer resist the great lesson; and you would be thrust inevitably by research into form. You need not be afraid of copying nature, not you, the danger for you is only that you may no longer see it, you may forget and misconstrue it.

Nature cannot aspire to a work of art, but only nature can make it possible You will never be servile to it.

Adieu, my dear Rouault: let me know about your work and your doubts. Discard everything that troubles you and all that gets in your light whether things or people. One does never scorn enough the reason one has for becoming angry. It is a man a third of whose life has been eaten up by anger who tells you this. One spends oneself through lack of patience.

I clasp your hand with affection.

André Suarès.

LETTER 51

To M. and Mme Suarès,
Villa St Hubert,
Hyères (Var). 28.12.1913.

My dear Suarès,
 You will accuse me of being negligent, I am sure, but you

would be wrong. I started this letter a month ago and I am writing it whilst working from time to time. I think of you too often, but do not decide to write to you unless I can write to you about painting, and had I done so sooner I would not have had anything new to tell you. First, let me ask whether you are in better health than you were during those last months in Paris, before launching out on this propitious subject. You probably are, or at least I hope so with all my heart.

Here we have continued to go through a painful phase. While my wife was getting better and putting on a little weight, as I hoped she would, the person we had with us, and who was satisfactory, fell ill. We had to replace her!!! And we hope very much to keep her and take her back. My mother is always cold, one has to help her to put on her clothes as she has stiff joints, she cries often saying she would prefer to be dead. Even though she is a shadow, what vitality she still has.

You will understand that I work in sorrow and sadness, my wife is never here. But by some inconceivable perseverance it seems that I will succeed in acquiring strange compensations.

Thus all my energies are deployed in different directions

Also it may be (I say, may be as I am very conscious of unforeseen difficulties), that I am moving towards unknown shores. In order to make myself understood, let us take the last few engravings which you have seen. Five or six of them we put aside, I had about a hundred of which some are quite large, but having inevitably worked less on account of all my worries, I noticed that although the subjects may be varied, neither techniques nor the emotion I feel in the presence of nature are expressed in them. These are types and even the landscapes are somewhat conventional. As for the colouring everything is done in black or sombre, livened up with reds from time to time

. . . I could neither render, nor copy, nor interpret what I felt, because I had neither the means of doing so, nor the material, nor the right values, nor the harmony, nor did the relationship between the parts satisfy me, because I had gradually to avoid certain materials and to find new ones to draw nearer to fresco, or if you prefer to find a pale material rarer than my variations in dark colours

I am on the way

Even my monsters are going to be bathed in light: already they are no longer monsters

I am not in the South of France, but here I have the sky, water and space, I do not benefit enough from them

I have been compelled to go out lately, because it is I who have to take the children for a walk these days

During these walks I have seen certain marvellous snow effects with an extraordinary changing sky of unbelievable delicacy in shades of sulphur, the background green and grey, then in a series of delicate pink, like the petals of flowers, in grades of pink and grey . . . on returning home I also saw and saw clearly, saw definitely, engravings in view of the exhibition. There now, you can say, you are talking nonsense again. No, I am riding a thoroughbred as Gustave Moreau said already after my *Child Jesus* and after the *Dead Christ*. He added modestly: "I won the Prix de Rome once and I mounted a donkey. You, you may break your neck but you mounted a thoroughbred."

I was able to sketch a crucifixion (in a little etching) where the body of Christ is one tone only as is the wood of the cross, the background and also the sky. Greenish the body, neutral red the cross, subdued blue, the sky . . .

I have left the engravings but do not think that I am a person who changes his mind, on the contrary, I am too obstinate, but I have just discovered an admirable law which I have, alas, not obeyed often enough. I was impatient, because I longed for immediate results I was too immersed in my immediate task. Please God that amongst all my other worries I shall become less so, I definitely feel that this is the achievement to strive for, and am nearly certain to gain time if I act in that way . . .

Georges Rouault.

Versaille 12.2.1914

To: M.A. Suarès,
Villa St Hubert,
Hyères (Var) sent to:
La Simiane, Petit Bois, Toulon.

... Yes, certainly, it is evident that I have had the foliage of spring in my eyes for the last two years, it is enough for me to walk along the road! I stored valuable impressions this winter! But believe me, my plastic and pictorial resources are not yet equal to my new vision.

... Looking at about ten of my paintings one could say: "There then, is what by his familiarity with the Masters and following the advice of Gustave Moreau he has achieved." I do not disagree with this.

Of others, the more important ones (about a score of paintings) one could say, (I am talking about someone sympathetic and perspicacious in this art): what variety, renewal and particularly joy in painting

More than ever I persist in an error (if it is one). A good painter can *paint anything*. Pray God that I will become one, and thus even a seeming error or hazard could nevertheless induce me to produce a work of art . . .

My ever more loving and precise observation of nature will lead me to an art more alive

Adieu, my dear Suarès, please let me have your news more frequently.

Notre meilleur souvenir et très affectueusement à vous.

Georges Rouault.

LETTER 57

Versailles 16.4.1914.

. . . How am I to thank you for your understanding friendship? Soon it will be impossible to live in Paris and even in Versailles if one has children: only today I looked over a large ground floor flat, three large rooms, three small ones, six hundred francs; but one must:

1) draw up a lease,
2) have no children.

With three children, my sister and my mother, no one would ever want us in Paris, and an appartment with studio would cost 2000 to 2700 francs.

On Monday you will receive a few lines from me for Vollard.

Georges Rouault.

LETTER 59

Versailles 6.5.1914.

. . . It seems that I am making *progress*, this is a delightful feeling . . . I have immense patience (in my art of course) . . . which would surprise many of those who think that life in art is easy, with two or three tints, two or three rough shapes carelessly spewed out.

I congratulate myself daily on not having shown anything to anyone, not even to those people (of which there are but few), who have a deep understanding of me or of my art and a very real friendship.

Oh, certainly I am a difficult person, but why should I not be? . . .

My thanks to Mme Suarès, sincerely yours

Georges Rouault.

LETTER 60

April 29th 1914
May 7th 1914

Though I have read little of Vollard's *Memoires of Cézanne*, they interest me greatly. You might tell him so when the occasion arises, my dear Rouault. It is full of wit with some piquant features. There is a sting in it and as it seems spiteful it must be true. It is possible that Vollard slightly distorts the anecdote and that he makes an arrow out of a feather. Was Zola then so small and shallow? Blind to painting and deaf to all music? Yes, I can believe it, but I find it difficult to believe in so much majesty amidst so much stupidity and baseness. Fundamentally everything is possible between secret enemies, I mean between a triumphant talent and an obscure genius.

Anyway, Vollard's account rings true. Vollard observes with malice and seems to be endowed with a good memory. Poor Cézanne, his eyes full of tears, rejected by his oldest friend at sixty, what a pitiful sight. I knew already that Cézanne is a saintly example.

So much the worse for Vollard, if he does not let me have his book. He may be sure that I will not ask him for it . . . Right! There is not one man in a hundred thousand who would instinctively do what he should.

A bientôt mon cher Rouault.

André Suarès.

LETTER 61

Versailles 12.5.1914.

. . . My work is better. I worked less last week but was more

relaxed. When painting *The Child Jesus*, I was able to work assiduously for fifteen hours daily for a whole week, but for better or worse, I do not put in that kind of work anymore.

Yours

Georges Rouault.

Have you among your papers a portrait of Verlaine to lend me? Carrière made a few, I think, (it would be for an etching).

LETTER 67

Plestin-les-Grèves
Wednesday 8.8.1914.

My dear Suarès,

. . . Here I am at 'La Source' St Efflam par-Plestin-les-Grèves, Côtes du Nord. One cannot get about any more just now, I do not even know when this letter will reach you.

I await Mr Rupp's orders. He begs me to stay where I am for the time being and not to leave my family.

I was also hoping to hear from you, I was afraid to trouble you, or rather knowing that you were sick I feared my visit would have been ill-timed

Yes, In Versailles I was feeling the same (as you were in Paris).

France, so discredited (sometimes by ourselves) is still, in spite of everything, like a rare work of art in this black and barbarous world

Here I admire the resignation of all these brave people: the sons and fathers have left, a woman yesterday went to the quarry to load stones into her cart.

Here I am anxious about my friends, my relations All the young people of my family have left, we are here without news, without newspapers, and it is impossible to find any.

But over and above, the feelings of my heart and family ties, my spirit is full of anguish.

Oh, it is not fear, for a long time now I have not cared for life (though in my pride as an artist I would have liked to make my small contribution), it is a completely different feeling and quite beyond me, as though a very beautiful thing might or could disappear; the opposite could happen too

. . . You cannot realize how this absolute solitude in this out of the way place weighs me down and how good it would be to receive your news, good or bad!

You can well understand, of course, what leaving with three children, my wife and my old mother means; I intended to stay away for three weeks and to see you as soon as I returned, and if I have not written to you before, it is because I know that the postal service is quite uncertain, in short, I am sending this letter without knowing when it will reach you.

Thank you for your kind letter which moved me and showed me what real and rare friendship you feel for me, that is cheering and comforting.

I hope to hear from you soon, our kindest regards to Madame Suarès and please believe always in my sincere and true friendship.

Georges Rouault.

LETTER 68

Plestin-les-Grèves
1.9.1914.

What hours I have spent here.

However much I harden myself, anguish overcomes me, my dear Suarès, without news for 20 days from my nephew, my sister . . . has just written to us. She has received four cards one after another.

He is in the 1st Zouaves, he passed through Paris, we were not there, then he was directed to Beauvais, no news since then, he told his mother that a bag with the cards in question has been forgotten. He should, according to the newspapers be nearing Charleroi. May God protect him!

My poor Lehmann* is in Bescancon, was born in Altkirch, also what emotion on our first successes, he will be in the forts or be sent to the frontier to support the battle if it goes badly . . .

I offered to return alone and to stay with the Station Master. M.R. would rather I stayed here, we shall see according to how things develop. I tremble as all my exhibition in Versailles is in the house there, they may just as well be at the railway station and in line with recent events in the event of an invasion the railway stations are vulnerable, the packing case could be reduced to ashes. I have considered going to an agency and putting everything into a depository. But I have nobody in Versailles who could deal with all this.

You once compared my efforts to those of an ant, but the gardener this time crushed my efforts with the blow of a Prussian boot. And with regard to the painting it is an urge which takes hold of one again and one does not know why . . .

The view of nature that I have here is beautiful, serene, luminous and comforting.

Thank you for the newspapers, they gave me great pleasure . . . whenever shall we meet?

Please write, I need to talk a little, in spite of everything, because this silence would be beneficial, were it not that this terrible vision intrudes all the time

Miracle! I have started to work again! You will understand under what condition.

With nothing! In a little loft! Just enough room to move! They are much less compelling than the last engravings but more like paintings But one more step! We will compare them on returning to Versailles if everything has not been destroyed by fire or machine guns. However, the paintings in Versailles are held up just in the course of execution also! . . .

What are you doing?

Our best regards to Madame Suarès, and the children send a kiss.

Very affectionately yours,

Georges Rouault.

*The painter Leon Lehmann, pupil of Gustav Moreau, whom Rouault loved like a brother.

Art is a great vice . . . they are right to say so: to talk of progress in one's art at such a time, how infamous! And yet . . .

My cell has little white walls, my endeavours do not produce ink stain anymore but beautiful even surfaces in lovely silvery light grey, and which will be varied at last.

LETTER 69

La Martinère
par St Malo-de-la-Lande
(Manche)
15/10/1914

I have taken my work up again . . . but I have been in distress for the last ten days

I have only just received all your letters, they were sent through St Efflam.

My wife dropped Madame Suarès a line a few days ago, telling her of our arrival here at the Letelliers'. You who are still in Paris, what would you advise me to do?

We can always return, but there are the children . . . and the risk of being lodged at the railway station* if the situation changed and the brutes returned to Paris . . .

Your letters are wonderful.

My dear Suarès, you certainly are a support to others . . . I hope to see you soon, probably, I repeat, during November.

My wife has received my detailed instructions, my friends Lehmann, Baignères, Maritain, Marguillier could give you useful advice . . .

The idea of death has haunted me** lately, however without sadness . . .

Best regards to Madame Suarès

Yours,

Georges Rouault.

*The house overhung the platform of the station of Versailles.
**The general state of Rouault at that time was very bad.

Versailles,
22.5.1915.

My dear Suarès,

I am sorry I could not come to see you last Monday as I had intended

My poor Lehmann saw the two wounded generals: Maunomy and I cannot remember the name of the other one; he is 30 metres away from the Germans and terribly exposed.

I find it impossible to detach myself from current events (except for landscape and religious subjects). Last Monday I learnt that a nephew of my brother-in-law, that I am very fond of, has been taken prisoner. I knew that there had been no news from him for a month To sum up my position I hope to have some 15 landscapes ready either with no figures, or at least where the lines of the landscape dominate and the atmosphere counts for very little: winter, spring, summer, autumn and furthermore ten religious subjects (1m x 0.75).

Regarding the rest (the exhibition will be just as important though the works will never be larger than 50 cm or 60 cm). I immerse myself completely into a mood of pictorial imagination which delights me

My little Isabelle has still to stay in Hospital, probably until the end of this month; Geneviève has returned home and seems well.

Our best regards to Madame Suarès and please believe in my sincere friendship. *A bientôt, un prochain Lundi.*

Georges Rouault.

LETTER 81

Anrachon
28/8/1915

You will think that I have gone mad and you would be right.
Everything here becomes so simple, that I sometimes feel like giving everything up and staying here.
This is childish.
However, here I am myself again.
This simple life suits me perfectly provided that I can correspond fairly regularly with a few friends.
I feel less isolated and more myself than in Versailles and I am so completely absorbed in my ideas and in my art.
The children take themselves off in a group, we do not look after them any more.
And how healthy they are.
And the winter is so mild.
But there is the museum, I know, and my wife's lessons.
And so many, many other commonsense reasons: the main point of concern is the children's future development and also, I must admit, my attachment to the museum and to the memory of my master.
"The heart has its reasons"*
There is a charming little school in the pine forest a few steps away . . .
Everything here is simple that is the attraction.
Concerning Vollard, you will do whatever you like, of course.
He does not seem to make unreasonable demands . . .
. . . Though I am lonelier than you can imagine, I am free from stress; notwithstanding what I could say against my four children, I have worked harder and perhaps better than I can say; but my ambition is immense, but the slightest blow, a child's squalling, something burning in the kitchen and immediately this ridiculous reality is magnified in my brain, my imagination keeps haunting me, and if I have been troubled or disturbed for one hour, I say "that my day has been ruined"

*French proverb: The heart its reasons, which reason does not know.

E

If I have not that false humility and that self-conscious studied modesty which sometimes shows a hidden and profound pride, I am nevertheless eaten up by it.

Yes, I have confidence in myself, but in spite of this confidence, I suffer hours of doubt, particularly when I am not fulfilling my 'functions'.

You see that I agree with you.

However, I think that this rest which I have taken is beneficial and perhaps it would be right and wise (I am so rarely so) to make a yearly habit of it.

My fault is that if I abandon myself, I abandon myself too much. That is a great fault, especially if one does not become hardened enough and is unable to make a choice.

Nevertheless have confidence, my dear Suarès; we must hope against hope and above all not be too impatient or anxious

This winter will see the beginning of my effort and next spring the end of it

My wife wishes to be remembered to Madame Suarès, and *croyez je vous prie, à mon affection. Bien à vous.*

Georges Rouault.

LETTER 83

10/11/1915

My dear Suarès, I would like to thank you for your book, but would prefer to talk to you about it personally. What can I say after what you have expressed: to begin to talk here about your *joinville*, God forbid, I feel incapable of doing so.

I felt jubilant, I will continue to be so that is all I can say. Besides, you will be pleased to learn, that I have remounted the saddle and am painting again, but I confess my inability to work on two ideas at the same time, besides I never could.

Among your admirable *Portraits** I already knew the one on Francis Villon and I re-read it with emotion — I shall take longer over *Ker-Enor*.

Portraits N.R.F., 1913.

I will have to read and re-read it: our lack of insight makes us assume, that we know our friends, whereas we go to our grave without having understood each other more profoundly.

This does not apply to you, but it does to me. You can discern better between the artificial and the fortuitous in life and extract the thought and heart of it by discarding virtuosity, routine and convention, etc.

Bien à vous and remember us to Madame Suarès.

Georges Rouault.

LETTER 84

11/11/1915

You would be quite wrong not to let me know what you feel about my books. Your loving them gives me great pleasure: a feeling which I rarely experience. You do not know how I feel, my dear Rouault. The brutes! I am referring to authors, critics and men of letters, all the scum who write. Would you believe it, not one, I repeat not one, has said a word, a single word about the *Portraits*, the *Commentaries* nor about *Péguy*.

At any rate, my scorn for these people equals their treachery and meanness. Therefore I do not complain. But one has to be made of granite to withstand such a tide of gloom and silence. Or rather one must in some way live with God, believe in absolute goodness and in the absolute dignity of paradise. Then hell is beneath our feet, hell paved with authors, false poets, false christians and false artists.

They ignore me, I can suffer, but I will not yield. I am a promontory, an old rock, a headland rather than an island.

However, I confess that in this universal repudiation I sometimes need to hear a good and loyal word, without which I would end up by feeling ostracized or alone in the world. A frightening thought verging on madness.

Thank heaven there are still a few people left to give me confidence both in myself and in them. You are one of them. There is no need for you to be a writer in order to be a good judge and to give me this feeling of great contentment.

There is no need for me to paint in order to sustain you in your work as a painter. But artists alone know how to talk to artists: one does not make mistakes when serving the same gods.

It gives me great joy to find you in the saddle again. You will have to show me what you are doing. I am anxious to see what you have achieved, especially your religious figures and your landscapes.

You need fear neither my criticism nor my advice. I do not give opinions but give energy. All I want is to infuse my strength into living souls in order to make them persevere or believe in themselves. How few are capable of this. How few can accept it! — Only an idiot, a doctor or a critic would advise an artist. The only requirement for the person who understands is to be able to see the essential, to draw the artist back to himself, or to raise him to the highest peak of his nature, but always in accordance with his own law.

Affectionately yours,

André Suarès.

LETTER 86

10.12.1915.

My dear Suarès,

I hasten to let you know of a happy event: the birth of my daughter Agnès on, December 10.

Unfortunately I missed seeing you (last time), about three

weeks ago, but I hope to be luckier next time.

Yours fondly,

Georges Rouault.

LETTER 90

Versailles
21/4/1916

. . . Patience! It is I who say patience to you. At Bernheim in May you will already see three of my attempts (1m x 0.75m) exhibited in a group; if you do not like this, the test of my exhibition is on the same scale. I took great pains to achieve the large, luminous vistas.

Georges Rouault.

LETTER 91

Versailles
26/5/1916

Dear Suarès, you have probably been wondering where I have been, as it is so long since I have been to see you, I acquit myself by writing to you from time to time, which is not quite the same thing. At last, on the 15th July we shall be in Paris. It is all arranged. We even thought that our little Agnès would not survive in this abominable house

. . . I have made a great effort, in spite of everything and in spite of my anguish!!

. . . Some of the *Orient* will please you, a sequel of landscapes in which I hope, reality and imagination are happily united

I am terrified of moving house (no need to tell you), but I confess that since the war I feel so inadequate, that though I have achieved some progress in vision and form, despite anguish and illness, I feel like some self-conscious lunatic who cultivates his obsession with art like a madman.

Bien vôtre and *à bientôt*

Georges Rouault.

LETTER 92

4/7/1916

For the last two months or more, my dear Rouault, I have been ill more than was apparent and more than I can say. I suffered from violent attacks the second day after Easter, which break me up completely: casting me down with pain for a whole week. And the attacks return just when I think I have recovered a little

A bientôt. Ecrivez-moi. Croyez à mon affection,

André Suarès.

LETTER 93

Paris
25/3/1917

My dear Suarès,

I was about to see you, but at the station of St Lazare whilst I was on my way to you, there was an alarm. I stayed there from 8.35 p.m. to 10 or 10.30 p.m.

Now I am about to depart with my four children, it makes them happy, as they are going to have a double holiday — Easter and July

It would be madness for everyone to stay here, especially as my unhappy mites are taken to shelters a long way away. They have just been ill for a week, these comings and goings make them ill.

Everything here is expensive, life there anyway will be easier

Bien affectueusement,

Georges Rouault.

LETTER 94

Paris
27/3/1917

My dear Suarès,

I am very touched by what you sent me.*

I intended to call on you, but the shackles of the family, of my old mother and lastly of dear Vollard who seems delighted with the drawings, but who gives me little respite, are strong . . .

I would like to come and see you on Monday, here I am in pain and distress and your book with its infinite sadness has done me some good, I cannot participate in other people's joys, but can in their pain even if it is ludicrous, only I do not show it.

The pain of human beings in general is rather like that of children, one can see them laugh and cry in the same instant.

Yours, even more so because of your book,

Georges Rouault.

*The Nation against the Race.

LETTER 95

L' Isle-sur-Serein 1917.

My dear Suarès,

. . . I do not forget you: whether it pleases you or grieves you I do not know, but like my good Father Moreau, though in a different way I cannot forget you. I feel I can understand you much better than you think . . . but I have no means of letting you know . . .

As I wrote the other day, I prefer the foolish Virgins of our Cathedrals to the wise and strong ones of our Ingres (their Dominique!). Too Roman, too Roman! Those of our Cathedrals have a different scent of virtue and above all a smile!

Georges Rouault.

. . . We do what we can! I am still preoccupied with my drawing in black for the typographical types.

I do not regret having started again. I have achieved an immense freedom with my Indian ink brush that is quite something, you know!

LETTER 97

Vermoiron,
par Vault-de-Lugny (Yonne).
11/8/1917

. . . Setting off with the whole gang was difficult.

This is a nice spot, very picturesque. My wife is just beginning to get a little better and has found some help.

I myself am more rested and go for walks when the weather permits; one day is fine and the next day is bad with heavy rain.

I am going to do nothing for a month, or at least very little.

I have a series of drawings for Ubu in white and black, and a hundred or so kept for September and October.

I do not intend to return home before the end of October, and (hope) to spend the end of the holidays alone in order to recover completely.

Besides here I can fortunately isolate myself

I put the article about me in the *Carnet d'Artist* aside for you which you will receive when I return

Before leaving there were two air raid warnings of German aircraft . . . we had the whole band of children with us that day. We were just about to leave and were worried on their behalf not knowing exactly what to do.

We stayed on in our fifth floor apartment so as not to disturb them

Please send me a line if you have a moment to spare, it would give me such pleasure.

My wife will have to wait until next year for Vichy, I am sorry that she has not been this year, but no doubt there were other people of greater importance than us

As always with my most affectionate thoughts and memories.

<div style="text-align:center">Yours,</div>

<div style="text-align:right">Georges Rouault.</div>

LETTER 99

<div style="text-align:right">Oct. 11 1917</div>

To compare yourself with Toulouse-Lautrec is ridiculous: there is no need to defend yourself, certainly not in my eyes, my dear Rouault. Where you resemble him least is where you could come closest to each other, you differ in your souls and all other differences are slight compared to this one.

Toulouse-Lautrec has never been anything other than a realist in the manner of the *Théâtre Libre*: *Antoine & his Pig*. Had he not been bitter and sometimes pathetic he would be

quite sordid. He has the eye and hand of an artist: his profession alone saves him from vulgarity.

His sense of form and colour makes up for his sentimental baseness, but not always.

Lautrec does not rise above what nature has bestowed on him; from it he chooses the vulgar streak and impure line only, in accordance with his character: perhaps he sees nothing more either in life or in mankind. He is only a quarter Huysman, before his conversion and mystical experience.

You, my dear Rouault, you run the risk of never being a realist, not of being one. You are tempted to turn your back on nature. You use it as pretext only.

You interpret and always invent: you are right in believing your vision to be that of a poet. You are poetic even in the pursuit of satire itself. Basically you are a prophet as far as a painter can be one.

This, moreover, is how your buffoons have practically nothing in common with my clown.

You see the buffoons and dolts as a lyrical poet imagines the horror and misery of a landscape.

My clown is quite different. He is not seen by the poet: he is the poet himself: he invents the landscape and does not describe it. Poet yes, and what a poet! In my opinion a great part of English poetry is written only about the clown. You will see the abyss which separates the clown from the buffoon from the following: Banquo, Polonius, Shylock himself and Caliban for me are clowns.

The buffoon is a victim of life and of the City. As such he is a serf; he is miserable. He is an object of compassion; you have made him thus: you have looked at him through charitable eyes.

The clown, he leads the game, far from submitting himself to it: the clown is wisdom or folly, its parody: he is full of irony, which is sometimes terrible, and with an eternal laugh. The clown of clowns, is the death's head. I make him say:

The clown does not need to be pitied: he would rather pity those who pity him. His silent laughter is steeped in haze and whisky: the haze is the covering of the Universe, and whisky is rightly called *'l'eau de vie'*.

A bientôt, my dear Rouault. Have good weather: it is horrible here.

Always yours, with affection,

André Suarès.

LETTER 101

Saumur, 19.12.1918.

My dear Suarès,

I am here held up by the difficulty of getting a reservation for the return, but am working on copper arduously, they sent me the plates, with that devil of a man.* One can at least always find some work!

During this winter or spring I think I shall have cut my fifty plates,** as soon as I am in Paris I will let you know.

Receiving your letter has given me great pleasure. You probably guess that I do not quite share your opinion. Calling Degas a wicked man is an exaggeration, though I would rather hear you saying this than myself say: wicked painter, in spite of our so called love of individualism, we are not so rich in real talents that we can afford to belittle them.

If I wanted, my dear Suarès (as you well know), to indulge

*Ambroise Vollard.
**They were completed in 1927, as a matter of fact.

in criticising this fellow . . . I could also enjoy myself . . . But the fellow in question is after all fairly important and this should not be entirely overlooked.

In this respect you make a good point, when you call him an embittered bourgeois, however I do not regard him quite like this — bourgeois, yes, embittered, why? What does he have to complain about? True, there is no need to have anything to complain about in order to complain, and how, sometimes . . .

Degas enjoyed an enviable and exceptional position for half a century but remained solitary. It may have been too elevated that position, I do not know, being neither a critic nor a prophet of the arts! However, what a favourite he was! At least of some special people and certain snobs! You hold it against him that he helped to make Ingres the vogue

I have always said and repeat it again and again: there is not only the drawing of M. Ingres, nor of M. Degas to be taken into account — not even in the sense to which their admirers have elevated them — but there is the painting . . . Cézanne would say, and their Dominique has pluck, willpower and drive, he is very strong, but not always a painter. Ingres would not have made certain pastels of dancers of Degas, and I prefer them to his Roman madonnas, to his great Jupiter, but what saves him is, that his serene somewhat cold and antique vision . . . has grandeur.***

Au revoir, please forgive this brief note — my best regards to your wife.

<div align="center">Yours,</div>

<div align="right">Georges Rouault.</div>

I hope to be there in January at the latest.

***Rouault said elsewhere (article, 'Ingres ressuscité' in *Mercure de France* December 16, 1912).
'. . . he endeavours to restrain the beating of his heart with a unique and masterful will, to dominate his sensibility'

LETTER 102

Versailles
26.3.1919.

My dear Suarès,

I have a small volume of *Paul Cézanne* by Ambroise Vollard for myself and I waited day after day to get the one I obtained for you, but time passes!! At last I have the pleasure of telling you that I have now got it in a de luxe edition with a dedication by the author which is the least I can do.

I am very happy about this, it does not compare, however, with your letter to Cézanne which is most beautiful.

After all you thought of Cézanne only whilst writing it and one can feel this so well!

From the living we get nothing or very little! One could almost regard them as being dead, to such degree do they forget the main point of life.

I hope to see you very soon,

Yours with affection,

Georges Rouault.

P.S. I hope to bring you the book before the end of the week, Saturday at the latest.

It is not Vollard's fault if the book arrives late: the de luxe copies were not ready. They are about to print a new edition as a result of the success of this one.

LETTER 107

Paris 15th April 1920

Did you suspect it, my dear Rouault? I was very poorly last night: with a headache that prevented me from keeping my eyes open. That is why I did not detain you.

Come next Wednesday, I shall be expecting you: we shall be able to enjoy one of those endless conversations, when one talks about everything and everyone as if one had been separated for a hundred years or has come from a different planet. This sometimes makes me chuckle.

The further one goes the more one should be an onlooker in this world: in order to see clearly it is advisable not to be involved. To act with others is to pledge oneself and to be tied. Everything we do in order to please, generally only debases us: if one satisfies others one tends to lose the best grounds for satisfying oneself. Three times out of four, when an artist attains success he ceases to deserve it.

Je vous serre la main et bien à vous.

André Suarès

LETTER 108

Marnat, Celles
(Puy de Dôme),
2/8/1920

My dear Suarès, please forgive me for not having sent you my news sooner, two of the children had to undergo an operation (nose), it was not serious, but nevertheless urgent, and then had I not hurried I would never have left.

Here I am at last staying with peasants* at a height of 900m., a change from Ubu , there is neither hotel nor inn.

The countryside is very beautiful, calm and exuberant.

I needed badly to end up this way. I think my wife and children will come sometimes somewhat lower down.** The district is beautiful and squalid and it is very difficult to find.

. . . I think from what you have told me, that you are going

*Rouault spent some time in Marnat where the painters Chasmy, Bouche and Heuré also stayed.
**Mme. Georges Rouault and her children stayed at the Inn of Chabreloche.

to stay in Paris. I would like you to have also a little, sometimes beneficial change.

In waiting for your news, please believe in my sincere friendship.

Georges Rouault.

I am giving my address to you only. I long for a little peace.

LETTER 115

1/10/1921
Friday

I am very touched by what you sent me and must say so at once, my dear Suarès.

The dedication* is too good for me; without having read your book, only giving it a quick glance at 5 o'clock this morning by smoky candlelight, this is all that I can say, and please do not complain that you are disappointed.

Poète tragique is too lofty for me, you frighten me when you talk of great poetry, and look how contradictory it is: it seems like an echo in my heart of an old and very powerful theme, as though sap were rising again in an old dead tree

Well then, your book will be read slowly and with perseverance by a poor, unlettered pupil . . . by an insignificant though devoted one.

I am suburban, very much so, in fact, and nearly exclusively so.

I have not been brought up with your great poets, nor with their heroes, and I hardly dare say they are more familiar to me than King Ubu, however this is true.

I do not claim to understand them but to love them.

There was no need for Gustave Moreau to make me consult

Poète tragique Ed. Emile-Paul, 1921. Dedication: *'To my dear Rouault, to enable him to measure the difference between dream and negation and because he is capable of infusing a religious soul into matter. With affection of solitary S.'*

mythology or a dictionary: merely hearing their names, echoes for me a past or future life, I was ready to see them in the secrecy of my trusting heart

I leave you now, having told you the gist of my feeling. *À bientôt.*

Thank you again with all my heart.

Georges Rouault.

LETTER 117

> Les Kermès
> à Carqueiranne (Var),
> 21 March 1922

Here I have been for the last month of four weeks, my dear Rouault. I can breathe, I am recapturing the country of my childhood and of my nostalgia. I always felt divided between Brittany and Provence. At Carqueiranne, between Hyères and Toulon, Provence is somehow more pleasant than round Marseille and Arles, slightly less Greek or rather less attic. Everything is more voluptuous, less dry and less harsh, but nevertheless it is the same light and sometimes the same lines, so pure and so bare. One learns the virtue of deprivation in the presence of these olive trees and these mountains facing the sea. Italy is much too adorned to be compared with this noble aridity.

. . . I adore the pines and olive trees: they are ascetic and they triumph wholly by being so.

. . .I did not greatly relish the palm trees nor the Flora of Africa until now. But here I can: they are happy and unrestrained. Then the pines cover everything. Is it possible to see anything more beautiful, more gentle, more alive and more noble than a beautiful pinetree leaning towards the sea? They are full of birds.

The weather has been mild and a little sad. Much wind, as the sea likes it. The sun bursts forth and shines, already everything is in flower and the sun's blessing extends to all the trees. At this time of the year the light has exquisite delicacy, these incomparable pale greys, that silvery gold, like the catkins of the willow, which people in the North ignore, because they never see Provence without prejudice. But Cézanne, he has not been blind, and well you know that Next year, if God allows me to spend the winter here, I will invite you to see the birth of spring between Toulon and Arles.

Adieu, my dear Rouault. Tell me about yourself and about what you are doing. I never forget you. I am delighted about you and your work. Please believe in my affection always.

André Suarès.

Go and see Betty, my dear Rouault; it will give her pleasure as well as me. She will tell you more about my far-off life and my retreat into Provence.

LETTER 119

La Simiane
May 21, 1922.

Do not hesitate my dear Rouault: *Miserere* is the best title. I have always disliked a mixture of Latin and French. The shorter the title the better it sounds.

I do hope you will consent to come down here one of these days. You must come and relax in these beautiful surroundings which restore harmony to one's soul. It is of an exquisite delicacy and variety. Nothing is more slandered than the Provence in thought and in colour. Daudet did not betray it any less than Montenard. The real Provençal is our Cézanne.

Between mind, feeling and matter, the divine balance is here. One morning by the sea is a marvellous lesson in harmony and if I may say so, a sermon on the Mount of Art. Even if we were not born in harmony we must strive for it alone. Never stifle the mystic sounds which dwell in you.

I think you have definitely found your way and will not abandon it anymore. As for myself I wish that without dissuading you from painting characters where you have such a strong and firm style, you should increasingly seek in your painting of landscapes, its transparency and luminous clarity. To my mind you could succeed in what has not been achieved for a very long time: the religious landscape. Corot is a delightful pagan, the Watteau of his century. Cézanne is the great Christian, the martyr of painting. But the mystic landscape not one painter has succeeded in creating for centuries, not since Rembrandt.

Adieu, Je vous serre la main avec affection.

André Suarès.

LETTER 121

Saint-Palais près Royan,
29/8/1922

I am in arrears where you are concerned, my dear Suarès. It was here that I intended to finish all the originals of the publications started I have thought of nothing else. I have not taken a single day's holiday since my arrival here. I will be at peace at last this winter. Having the right ideas at the moment which may escape me in the future, the execution of them will be a rest in comparison.

I was not able to return to see you and left in a hurry.

I can assure you that I will have profited much more from these two months than I would have in Paris during the whole winter.

Here the children roll about in the sand, but two steps away, we can leave them alone, or with one adult to watch over them.

My wife is not in so much pain, but has taken a long time to recover from Aix, it is only now that she feels the benefit of it. This part of the country has a delightful climate.

How is Madame Suarès? My wife and the children join me in asking you to remember us to her. Please believe in the affection of,

yours

Georges Rouault.

P.S. I always hope to find myself somewhat lulled by the countryside which is good and delectable, I will be so this year, but even more so next year.

LETTER 125

Paris, the 11th May 1923
Friday evening

You know then, that I am the same age as you, born in Provence. This is all that is needed.* I will tell you a little more, if you wish, but it will be for you alone. Do not forget that I do not want to make my presence felt in any way. I am not a candidate; I never have been one, I never will be one. It must not appear that I supply you with notes like all the others do. You are my friend. You know me. That is sufficient.

In one way you enjoy a great privilege. You want to reserve it for me: you have taken that decision, because it satisfies your feelings and your mind. I receive the prize from you, if they give it to me, because as matters stand with me I have no right

*A list was required of candidates for the painters' prize, a literary prize conferred only once and that to Paul Valéry. Ambroise Vollard presided over the judges, composed of about twenty painters.

to refuse it: my life and future work depend on it. This is the truth. For once there will have been an artist who thinks of me and renders me some justice. Your wish to vote for me to the end is what pleases me and gladdens my heart. Had I your vote only, if yours were the only one, your vote would be enough for me. This vote honours us both, the one through the other, and besides it classifies us. Our double character is inherent in it. One can search in this world of vipers, skilled in all intrigues, without finding three as pure as we are: whatever may be thought of us, my dear Rouault, we are the only two who owe absolutely nothing to anyone, the only two who are really alone and practically outlaws. Thank God you met Vollard. There is no Vollard for poets; the writer who is completely free, who does not belong to any party or to any sect, has everything and everyone against him. This law is the law of the jungle, I mean the men of letters. Vollard's prize is in my eyes purer than the others, it is more honourable, because it is not awarded by men of letters. I have never been one: hence my banishment.

Adieu, dear Rouault. Till Sunday evening. I shall never forget your enthusiasm for my cause nor your warmth in this matter. We shall laugh about it later, whatever the issue. For the moment, believe in my great affection.

André Suarès.

LETTER 126

Paris, the 15/6/1923
(Pneumatic)

My dear friend,

You were right.

I will explain it to you and talk to you in greater detail on Wednesday. Some members of the Institute have said, that if the prize is to be shared they would then vote for Valéry and for Suarès.

The first round showed an enormous majority (for Valéry). I

myself, according to your instructions, went to tell the journalists downstairs, that Valéry won by 15 votes (I do not remember exactly but approximately) and I avoided mentioning your name.

I am somewhat ashamed.*

Yours — very affectionately.

Georges Rouault.

I prefer not to see you before Wednesday.

*Rouault & Matisse alone voted for Suarès.

LETTER 128

25.8.1923

My dear Suarès,

Things have happened, beastly things; Father Moreau was absolutely right.

One struggles, full of hope, from morning onwards with a wild animal, and by the evening one is overcome by it; but from this I seemed to have learned, I think, a good lesson and a lasting one this time, I hope.

A certain expression does not go necessarily with a certain execution.

There are no lines in the fire, but only shapes.

To wish to apprehend more completely is sometimes misguided; we will talk about it better by word of mouth, but I am pleased nevertheless with certain pieces, with most of them; luckily I stayed to save them.

Very affectionately,

Georges Rouault.

Les Kermès,
à Carqueiranne (Var).
19th December 1923.

When shall we have an evening together again, dear Rouault, and resume our endless, weekly conversation on art and on the life of artists. I feel your absence and await you, in spite of me, even here. I would like to have you here in this country with its classical horizons. It would do you more good than Italy. I would open your eyes here to an unknown world: because of all the people I know today and who live in a world of forms you are the least pagan.

There is a sphere of feeling, a closed universe, a mystical thought, where I have no other companion than you. And I know that you yourself have no one who understands the depth of your own nature on that higher plane, where prayer and the ardent search for an ideal truth intermingle. What is least known about you is without doubt this desire to turn a religious feeling into lasting beauty, even though it may seem horrible and scandalous to the Pharisees. The Academy is the Pharisee's temple of Art. They cannot admit you into it for that very reason which made me perceive the meaning of your life's work at first sight: you search less for the shape than for the expression and you cultivate so much beautiful material only to subordinate it to feeling, *ancilla Domini*. I love this manner and relish for redemption which you sometimes pursue at other times send to Hell. That is what extricates your tramps, your prostitutes, your beggars and all your monsters from horror and degradation: the beautiful material in which you have clothed them vouches for their soul, making their misery also worthy of salvation. The noble, the good Moreau was not mistaken in you, my dear Rouault, neither was I, I hope

Adieu my dear Rouault. All best wishes for your happiness and that of your wife and children.

I am always yours with the same affection.

André Suarès.

LETTER 134

Les Kermès,
Carqueiranne (Var)
21st March 1924.

It is true, my dear Rouault, that for two months I had promised myself to come to Paris. I was to be summoned there for a matter of great importance: the summons has not come yet, and I could not add the cost of such an expensive journey to all our other expenses. But however, it will not be long, I think, before I return to our lovely, admirable and terrible City.

I know nothing, not the ghost of a word, of all the stories which you tell me. Therefore I have no opinion on them. Whatever you do will be well-done, for your heart is in all your actions, with your conscience untainted and clear

I am therefore sure, that you have done what you should have done and said what you should have said. I don't do any reading here and I throw newspapers away as though in a rage. You are the sole judge of the influence I have had on you. It would be quite absurd had I had none: it is as much to your credit as to mine. We are certainly united by the mystical foundation of our natures and by an irony which responds to the invincible need to be true. My kind of irony is as different from yours as possible; but the irony itself springs from the same unfettered strength. I think that no one today has anywhere near the independence of spirit to equal ours. This is what has set us apart from everything and which forms the basis of our dealings. With God's help dare I say that we share a kind of purity of soul which neither of us could find except in each other. You have a natural leaning towards the horror and

misery of man, like an avenging monk who uses the wretched to humiliate the great and the fortunate of this world who are its most deceitful. As for me I do not so much wage war as reflect on it. I have long been Apollo's archer, who shoots arrows at all that crawls. I prefer now, while others shoot, to sing the battle cry, or better still the anthems of purgatory and of the meadows of divine peace.

Courage, dear Rouault, go on working. Do not change works which have satisfied you! We have but one life. Yesterday is not today. I have great hopes of your exhibition. Tomorrow it will be nearly fifteen years since I had no doubts as to your worth: if with your gifts as a painter I urge you once and for all towards the serenity of light, you would astonish your enemies even less than your admirers. Nothing is more tragic than light.

Always yours with the same affection.

André Suarès.

LETTER 135

Paris 28/8/1924

My dear Suarès,

I hope to see you next Thursday; I have bad news about my mother, I cannot leave, as I am on the *qui-vive*.

Next Thursday then, unless . . . but you will be informed.
Yours,

Georges Rouault.

My mother informed me of her wishes a long time ago. Distant relatives are away on holiday; everything will be done simply and in private; my poor mother is 81 and of whom her sister, who looks after her, said she is so gracious (meaning her friendliness and kindness) will go to the small cemetery St

Louis of Versailles, where my father is already buried. For my mother and I, common suffering bravely endured, created more solid ties, than could have done false pleasures, and the sneers of the blasés and the sceptics.

LETTER 138

Paris 17/10/1924
Friday

. . . I have a copy by A. Vollard of the *Degas* to deliver to you. As far as I am concerned, alas, I do not feel very rested, I still feel much grief* and inner weariness.
Yours affectionately.

Georges Rouault.

*Death of his mother.

LETTER 140

1924

*. . . you were the first who raised me up again when I was 'exiled' in Versailles, with a letter expressing so much faith, which I will never forget I confess that I was rather low (then), though without wanting to brag, I may occasionally have had some pluck . . .

(Since then) everything has been resumed with incredible vigour and under awful and even deplorable conditions. At present the light, which I did not have hitherto, seems to be of great help to me.

Father Cézannes, you would be pleased.

I never betrayed you, nor imitated you and believe myself

*The first page has been lost.

more than ever to be painter and to know myself.

Lhote has paid his debt, different in this respect from so many hypocrites, humbugs and imitators. He made in his last but one copy of *L'Amour de L'Art* a rather convincing confession in an article about me.

Georges Rouault.

LETTER 142

Paris, 12/4/1925.

This time, dear Rouault, the Easter egg is not empty. As you well know I do not set any store by your having been awarded the ribbon;* but I am delighted at the thought of all those who do not scoff at your having received it: they will not even be able to say anymore, that your contemporaries ignore you. The officials do themselves honour in honouring you.

. . . Let us have your news, and please believe always in my great and already old affection.

André Suarès.

*Ribbon of the Legion of Honour.

LETTER 143

Paris 24/8/1925

My dear Suarès,

It is not one, but ten letters that I should write to you, to tell you that whilst awaiting October, you are always in my thoughts.

Since we have become separated, I am like the bird on the branch — Do you sing, little bird?

At least do you paint, poor Rouault?

To return to myself, I will tell you, my dear Suarès, in greater detail what I have been through.

You will quite understand, and there are not many who feel and understand it, that it is painting which is the cause of this need to withdraw from everything temporarily, even from the most treasured and friendly conversations (painting . . . and those things which fly at your throat like wild beasts and of which one has to rid oneself at all cost . . .).

I will not fling myself into more or less subtle theories at the moment — but I hope soon to send you or better still to bring you, on my return, the article for M. Dayot, on Moreau, which I dedicate to you. You are certainly the one with whom I pursued the conversation — quite often — on this topic so dear to us. Have you kept what I sent you through my friend Lehmann? We shall look at it to select the best.

Meanwhile I hope you are in good health. I may perhaps go to Aix by car. Have you got some tips to give me on interesting things to see on the way, surely, *there must be no lack of them*. Maybe the journey will not be taken before October, it is my work which calls the tune, as you will have guessed; Gustave Moreau said of me: "When one sees him disappear, there must be a pictorial crisis," a crisis which interests people less and less.

It has been terrible today, I am practically pulled down by it . . . I who thought myself more or less settled, find that I have to lean on nature more and more

Please believe in my very sincere and true friendship.

Georges Rouault.

Even before having become acquainted with Gauguin, Cézannes, Van Gogh, I had abhorred already that false copy of nature, average, even well done . . . but . . . above all mediocre.

This is what they forget, those who label everything and want me to be romantic

I have a horror of just that false richness of the false stained-glass window. This *Tableau vivant* which has lost the art of the stained-glass window.

. . . I had much more love for a purified form and for a

refined harmony than for all this old romantic sham . God knows what rubbish I know in this field.

Very affectionately yours,

Georges Rouault.

LETTER 144

Paris 2.9.1925.

Do not think, judging by this letter, dear Suarès, that I am mad and delirious.

One would think, that in spite of appearances, I have a good head on my shoulders, but should I let myself go and talk about painting (which intoxicates me) I would talk drivel.

I was full of gloom as you may suspect — and slightly ill and suffering, you are astute enough to be aware of this, and I was caught . . . I had to abandon all hope of thinking about your *Soir d'Emaus* and about other matters had I not made a tremendous effort to free myself, otherwise I would have been swallowed up. I have done this with some physical strain. I am only able to proceed swiftly. I hope to drop in on you at the end of September or mid October. Do not tell anyone at the moment, I would be choked on all sides and I must breathe a little before hurling myself into the whirlpool.

I make no complaints, the great effort of painting is made What weight off my shoulders and off my brain, but how stupid to have agreed to re-start everything in painting.

I hope that you are feeling fairly well and I would be happy to hear from you if possible.

Believe in my true friendship — I grasp your hand with affection.

Georges Rouault.

LETTER 146

(1925?)

My dear Suarès,

During a terrible mistral I climbed as far as Cézanne's studio (the gravel and pebbles were blown into my face); the view from up there is very beautiful.

I found more than one site there, far from that tempestuous *Mirabeau* who comes from Paris and is displayed in one of the large squares; when I first had the idea of that little fountain, I did not know that Aix was a town full of beautiful doorways and fountains: exquisite carvings can be found at every step.

Please forgive my being brief, my eye has become worse on account of this terrible wind. I am endeavouring to avoid writing, but I will get better if I stay indoors for a few days.

If you want to write to me, my new address in five or six days time, will be: M.G. Rouault c/o M. Thorndike, Nice, (Alpes Maritimes), 57, Avenue de l'Imperatrice-de-Russie

I do not know the names of the thirty pupils chosen* but I do know that Lehmann was turned down, at least he has not yet been told anything. That hurts me for him, being so devoted, so modest, but I will make arrangements for him to receive some very real compensation in the future.

I will write you a longer letter soon about the beautiful countryside so unclassical in the accepted sense, but so very classical notwithstanding.

I grasp your hand in friendship.

Georges Rouault.

*The reference is to an exhibition of Gustave Moreau and his pupils at the Gallery Georges-Petit. Later on Lehmann was represented.

(Spring 1926)
Thursday

Dear Suarès,

It seemed that you were interested in this book, *Souvenirs intimes* — I want to tell you that it is going well. (I am carrying out) with ardour and passion — the lithographs have been worked with infinite patience on the stone.

It seems to me that yours will succeed and go admirably well with the others.

If it is not taking too much advantage of you, I would be very pleased if you would kindly go over the whole book and revise it including the Gustave Moreau as we were not able to obtain the manuscript from D. — it had to be recopied — it may be advisable to shorten it.

Also concerning Degas . . . I hasten to let you have the list of the portraits:

I	André Suarès,
II	Baudelaire,
III	G. Moreau,
IV	J.K. Huysmans,
V	Léon Bloy,

(I think that the J.K. Huysmans is superior to Léon Bloy).

VI	Degas,
VII	Renoir,
VIII	Daumier,
IX	G. Rouault.

Souvenirs intimes, I am glad that I embarked on it — considering the turn of events. You were afraid . . . that I would be carried away by literature — Oh no, my dear Suarès, do not fear this, rest assured that my thoughts, supported by my lithographs, rise above it.

. . . I am sorry that all this is falling on your shoulders — in

addition to the book which has to be published in a fortnight
— but it seems to me that you were keen to do it, and you
yourself act with such discretion that it is a pleasure to
communicate with you.

You respect the secret thoughts of people — how rare this is
— whilst others . . . could not care less — they do not even
sense them, are not aware of them — how then can they
respect them! You will, I think, have the lithographic plates
and the book — we shall talk about this on our return. L.
Lehmann will tell you a little about it.

<div style="text-align:center">Sincerely yours,</div>

<div style="text-align:right">Georges Rouault.</div>

LETTER 153

<div style="text-align:right">Nice, 5/4/1926</div>

Dear Suarès,

I was in no way disappointed — by the countryside — my
imagination has not deceived me, but I am a little intoxicated
by fatigue and I really should go right away from these
propitious places — to find my way again and even in order to
see it quite clearly

I shall come back — on account of the precious elements I
have found here.

It seems, according to Dayot, that my panel is marvellous.
Do not believe it — as a matter of fact, in a fit of madness, for
good or ill I do not know which, before my departure (irritated
by what I heard about the drawing of the *dead Christ* which I
did when rather young) I scrubbed out three canvases of
which two were larger than two metres — two landscapes and
one Christ on the cross a little smaller — canvases conceived
in 1913.

I confess that I was at the end of my tether and that I hardly
knew what I was doing — it was as though I was intoxicated,
but a small vestige of willpower still sustained me. There is a

certain autumn (horses taken to the water) landscapes rather limpid — sky ultramarine, and another landscape, *Christ and Disciples*, the harmony of which satisfied me.

— Exhibition at Petit the 15th at 10 in the morning.
— Open to the public at 2 o'clock.
— Hanging of the paintings on the 14th.

The trains are packed, one has to book one's ticket in advance — I do not know whether I shall be arriving on the 15th, I hope I will.

I sent a few pages to *Correspondant*, to *L'Art and les Artistes* you know about it, to *Nouvelles littéraires* or to *L'Art vivant*, but I will not agree to interviews, only to questions written down to which I will reply in writing.

My guardian, who nearly lost his wife, is on tenterhooks waiting for me. Dayot seems delighted and A. Vollard is full of goodwill, I hope he will not forget the frames the day before. I asked a friend to jog his memory. It is required that they be not more than 5cm.; even so I go beyond the 1.80m. allowed. The best canvas will be placed, I think, at the top (No.1), *Crucifixion* (No.2), *Christ and Disciples* (No. 3), — then two small ink drawings (Nos. 4 and 5).

Best regards, and I hope to see you soon, I grasp your hand in friendship.

Leaving saddens me, but I hope to keep the luminous vision.

Georges Rouault.

LETTER 154

Paris 16/6/1926

I need to see you urgently for 10 minutes or a quarter of an hour, dear Suarès.

You look like a blind person* and they are waiting for the

*In the last state of the lithograph which Rouault prepared for *Souvenirs intimes*, Ed. Frapier, 1926.

final retouching for printing. I thought this evening of writing a little rough information in pencil concerning the eyes: it was a tour de force to have worked from your photograph, the size of a fingernail.

I shall see you on Saturday evening at about nine o'clock or on Sunday if you prefer it I am going to deliver the five which are ready for printing, there is only you and Baudelaire left, but of him I have excellent records. In spite of this you will not be treated any worse, only you have given me much more trouble. But I do not reproach you for this.

Bien vôtre

Georges Rouault.

LETTER 155

Paris, 28/7/1926

Dear Suarès,

I hope your stay in Arles is good and that you have at least found approximately what you wanted — is Madame Suarès' health any better? I hope so.

As far as I am concerned here I am near the time of my departure overburdened for the following reason: because I have to leave two months' contracted work for the artisans to get on with.

. . . My family is in St Servain . . . I have the good luck to have a car at my disposal

Yours sincerely, my dear friend, I think of you, but it is so difficult for me to *leave*, that I put off writing to you from one day to the next in the hope that I will do it better when I am on holiday.

At last I am somewhat relieved from my stiffness.

Hope to hear from you soon.

Georges Rouault.

Write to me rue La-Rochefoucault, it will be forwarded.

G

Avignon, 1926

Here I am in the Provence, my dear Rouault. I had to leave as quickly as possible. Without considering me as ill, the doctor advises me to rest. I can't last out this continual insomnia and state of tension, which can only be cured by a sudden change

Here the sky is purity itself. The air divine. The solitude unbelievable. I am talking of Les Beaux. I arrived at Avignon only this morning and will not be here anymore tomorrow. Avignon is one of the most pleasant towns I know. As for the Palais des Papes and Villeneuve, there is nothing more beautiful. You must see these marvels, at least in passing, when you travel in the Provence later on.

When people tell us that it is raining in Paris and that it is almost cold there, we can hardly believe it. You too, my dear Rouault you also would need to give yourself some rest. You just learned to your cost how dreadful it is to write a book and yet you did not have to trouble yourself with the typography, the outlay, everything that makes this art so great, so difficult and so delicate for the printer.

Look here at a corner of Les Beaux. You will appreciate its powerful character. Add to it its incomparable light, of an extraordinary lustre and gentleness; a sky purer and vaster than the open sea. Nothing equals the grandeur of this countryside, save perhaps its charm.

See you soon, I hope, I clasp your hand with affection.

André Suarès.

Paris, 26/10/1926

I am happy, my dear Suarès, to send you some news, which I think is good and which will compensate for my long silence.

As usual my return to Paris was painful always for the same reasons.

In short this is what I want to tell you.

Would you agree to this:

I have some engravings to carry out in colour (do not talk about them to anyone because they represent some very special researches). Would you then agree to make a text for *Cirque*:

1 Will you make them pay you for your original manuscript a price you think appropriate?

2 Will you lend it only to M.A. Vollard and then retain all the rights?

As soon as he receives your reply he will give you a firm answer and come to an agreement with you or if you are going to return soon you could negotiate directly with him, as you wish.

You are already familiar with some of the originals, I have worked on them and I will be able to show you some final plates in colour on your return.

Since the *Painters' Prize* I have always thought of some compensation

Best regards, I grasp your hand in friendship.

Georges Rouault.

Paris, 7th November 1926.

It is raining in torrents, it is eleven o'clock and it is dark. It seems to me as if I had dreamt of the sun, dear Rouault, in a former life. Four days ago I was still there. The most beautiful dreams are those which fade the fastest. And now I have returned into our sublime hell. I suppose that the damned cannot dispense with the fire. You waited for me at home. I must tell you how moved and touched I am by your concern for me. Your thoughtfulness charms me. I love and appreciate your loyalty immensely. The old Breton foundation reveals itself: the ground is of granite underneath all those useless roads, full of mud and pot holes. Of course I will always be delighted to work with you. I know you so thoroughly: I was always able to see into the core of your being: the almond guards the rays which the dark pulp retains and the bitter shell prevents from appearing. Together we will examine what can be done and which is worthy of us both: the harmony must be found which will make a rare and beautiful chord of our so different natures. But we are united by our Love of God and the passion to do our utmost.

I grasp your hand with affection.

André Suarès.

We hope that all is well with you and that your children grow in joy and rigour always.

I will see you on Wednesday evening then.

We shall continue our conversation interrupted by the summer, you ardent traveller. We have so much to tell each other, that we shall still be talking at one o'clock in the morning.

LETTER 163

Paris, 12/11/1926.

Please forgive my troubling you again.
Would you be so kind as to hand over your small portrait to
Lehmann as soon as possible, because I would like to return it
to you before I leave.
. . . Wednesday evening I will make a few light sketches
without making you sit for too long . . . after which I will leave
definitively.
L. will come on Monday at about 4.30, please do not forget.
I will be delighted to put your portrait into the book.
Very sincerely,

Georges Rouault.

LETTER 164

15/12/1926
Monday evening

Dear Suarès,
Well, I have gone away for a few days — do not mention this
to Vollard just in case a tile falls on my head before leaving.
And do not negotiate anything firmly, I mean: definitively,
before my return, though you could mention under what
material conditions you would undertake this work (this is
none of my business . . .).
I would like to show you two or three samples first; from
Friday onwards they will be in the hands of the engravers —
however I would prefer for some other reasons for us not to
precipitate anything.
Better discuss it by word of mouth, do not count on me on
Wednesday next, I am not certain whether I shall be back the
following week either, you will be informed of my return

I have read your book:* not entirely, but enough however to be able to tell you that 'you are a painter'.** . . .

*_Présences_ Ed. Emile-Paul.
**Dedication to Georges Rouault from André Suarès: '_To my dear Rouault, real painter and faithful friend._'

. . . I have bought Dostoyevsky's book for my daughters, I mean the one written by his daughter for which you wrote the preface; have you received my long letter during the holidays in which I mention it?

. . . See you soon — you are always present in my thoughts — and if this presence is not the only indispensible one in this life of pitfalls and strife, let me be hanged

<div align="center">

Bien vôtre,

</div>

<div align="right">

Georges Rouault.

</div>

LETTER 165

<div align="right">

Paris, Xmas 1926.

</div>

I will expect you on Tuesday evening, my dear Rouault, I will arrange for us to be left in peace. Do come. I am anxious to see you before the end of the year. We shall make Libations to the new one. When one is over nineteen, how sad these days of decline are: there is something unrelenting about them, like the severity of a creditor who has sworn to make us bankrupt . . .

With Vollard we are in perfect agreement: he has that virtue of leaving us both entirely free. This is a rare enough virtue and we must be thankful for it.

. . . Well then, till Wednesday and as always with affection.

<div align="right">

André Suarès.

</div>

Thanks to little Isabelle, your big daughter: she has done us a service. Her handwriting is beautiful and she will make you a perfect secretary.

LETTER 166

1926
Thursday evening

Dear Suarès, I postponed my departure for a few days on account of that shocking weather. I will expect you here on Wednesday then, unless I hear to the contrary.

I pray to the good angels to sustain me, because I really feel without false humility unworthy of the place you concede me

I am faint-hearted and foolhardy at the same time. I observe what comes out of my brain and from my heart with apprehension and distress I was not made to be as terrible as they say I am, but when I look again at some of my old or present works, I feel like Orpheus in the sombre abode of the dead.

I live with them, I love and communicate with them through their works, a strange occupation for a living soul.

It is life that has plunged me into this deep styx, and I will always be torn to pieces, you have said so and I believe it

I believe in suffering, for me it is not feigned; that is my only merit. I am crazy about painting, and like a child, I still hope and dream of some marvellous garden, a Promised Land where I will not be allowed to enter in this life.

But without wanting to elevate myself, or to erect my own statue, I would like to state, that those who have taken thirty years to see (as they say they do today) the trace of Sin in my work, my dear Suarès, are very blind.

We are undone: my clowns are not so much dispossessed kings, their laughter is familiar to me, they touch on the insanity of repressed sobs and bitter resignation with which I am well-acquainted

Empty gestures and virtuosity with an unfeeling heart are alien to me.

What we are, we expose so well without meaning to, or knowing it

One is so modest, so small, so unpretentious, but at the very moment our self-respect, interest or our pride is trodden down, the dove turns into a viper and a most horrible mongrel, an angry roaring lion

Sometimes one has to smile or even laugh at oneself in order to keep one's balance. Certain people have often reproached me for this smile at the corner of my mouth, for this internal smile, as they call it, which seems to originate from men of the church and from the clown

I take no pride in stating that I am not of my time, it is not my fault, others are proud of regarding themselves as modernists , but are they? It is easy to stick a label on to goods, in fact only too easy: the objectives make fun of the subjectives

Form and colour, that is our language

Georges Rouault.

LETTER 168

Paris, 24th of February 1927
Thursday morning.

Come tomorrow morning, dear Rouault, if you can I am afraid I will not be at home next week Ash Wednesday So much is on, a great many concerts to which I am so rarely invited, that I do not always turn down the invitation when I have not listened to music for a long time. I could even succumb to a woman's call or to that of a flute. However, they make quite hideous and poor music these days: with neither thought nor feeling. They have at their disposal an incomparable palette; but they are neither painters nor poets. In short, what these musicians lack most, is music.

Tomorrow, I hope. Farewell. And always

Yours with affection.

André Suarès.

LETTER 170

Les Beaut, par Maussane,
(Bouches-du-Rhône)
3rd July 1927

You are still in Paris, my dear Rouault? I have been here on my rock for the last three weeks in the sunshine and in the wind. The weather is bad everywhere, even here it is not particularly good. But at least there is always the light.

I hope to send to Vollard either the *Clowns* or the *Passion*; or maybe both at the end of the month

I presume that he has sent me his *Sainte Monique* . . . Vollard certainly has a lively wit. There is in his novel a strange perversity: it is deliberate and involuntary at the same time; unconscious and considered; malicious and without any explicit intention to harm. This blend is part of his talent. His soul turns naturally to parody. It seems as though his diverse origins of blood and climate mingle in him to combine diverse streams into one spray: the drops fight whilst mingling, some nearly pure, the others perverted. Vollard is timid and dangerous: moreover he is a man of letters; and after all he is more worthy than most of the others.

Adieu, dear Rouault. Do have a rest. You absolutely must, in order to be able to continue to paint and finish your canvases. Do not waver anymore. I feel that you have reached a critical moment: you have achieved victory now: do not spoil it. You have known how to win: do not damage your future.

Please believe in my long standing affection for you.

I grasp your hand.

André Suarès.

LETTER 172

Paris, the 7th November 1927

Are you back, dear Rouault? I have been for sometime and am expecting you. Come from Wednesday evening onwards, the day after tomorrow, if you are free. We have a hundred things to tell each other.

How touched I am by your loyalty to me. All your intentions are good: you display a kind of solicitude towards me which is more precious to me than any results it may produce were they even of the highest order.

I have left the sun. And I look for it with anguish: I search for it inside myself like Athena's bird, the owl closes its eyes only in order to see the sun clearer. Let us not lack at least this light.

I hope to see you soon, and with the same affection always.

André Suarès.

LETTER 173

Paris, 15/11/1927

I have received your letter and am back but booked up.
Wednesday is not possible, but unless I hear to the contrary I will see you on Monday next, or if not Monday then

Wednesday week.

Your letter has touched me greatly, but everything you say is in my line and natural to me, it is you who enlighten me about it — as a matter of fact I abhor capriciousness and a changing frame of mind, I like continuing efforts, and a persevering and faithful friendship.

I have suffered too much from hollowheads and unfeeling hearts without moreover demanding anything from them.

Georges Rouault.

LETTER 175

Without date
Wednesday

Dear Suarès,

. . . .I have seen the spring here the reaction would be salutary if my stay could be a longer one. It would be balm for my work.

I would become a solitary savage once more and happy to be one My ideas will crystallize after having seen spring for two or three years, then I will paint *Stella Matutina* and *Vespertina* God will (or more simply: *Morning* and *Night*).

This would be but the calmed and more contemplative rhythm of the heart and the mind of a painting

How they make me laugh with their expression: love the young . Encourage false vocations, drive the flock into the fields of mediocrity, that is some people's supreme skill.

Love the young , would it not be more appropriate to attempt to give the best of oneself, far and beyond any more or less clever policy

Saturday evening

I have spent a fortnight now scrutinising the same horizon.

As in former days when seeing travelling shows, or at fourteen in front of old stained-glass windows, forgetting everything and forgetting myself, I discovered this fundamental truth: a tree outlined against the sky, has the same

interest, character and the same expression as the human form. The question is how to express this: the difficulty starts there

How often have I not met in the studio those good at schoolwork! In front of the model they began at the tip of the head and by the end of the week or even sooner they have finished down to the last reflection on the toenail.

Whereas I felt dwarfed by the task of rendering the colour of a grey wall turning to silver and the naked flesh coloured in delightful tones according to the light.

The taste of variation in tonality is a joy to the eye and to the mind, but it is also a monumental labour.

The good advisers amongst my friends said "You will soon tire of nature." On the contrary, should the obdurate visionary or the epic poet spend a thousand times a thousand years examining it in diverse and various ways, it would always remain the propitious source for new growth.

Until Wednesday the 18th and *bien vôtre*.

Georges Rouault.

LETTER 178

Siena
The 23rd September 1928.
Sunday

In haste, my dear Rouault.

You can see where I am: I have been travelling in Italy for three great weeks, it may be four, I do not know anymore. I will not be home before the fifteenth or twentieth October. You are taking a rest whilst I strive hard. I am delighted to hear about the peaceful time you are enjoying and the pure air you are wise enough to breathe.

I will then finish *Le Condottiere* after leaving it to meditate and tormenting its heart for fifteen years.

. . . I am here in the town of the Virgin Mary. My editor is with me, Daragnès is accompanying us: it is he who has to make the plates. He is sending you his salutation. He likes you very much. Knowing me, he will like you even more.

Adieu, my dear maker of stained-glass, Man of Chartres, I shake your hand with the keen affection you know I feel for you.

André Suarès.

LETTER 179

Gryon (Switzerland)
27/9/1928

M. André Suarès
Siena (Italy)
Poste restante

Dear Suarès. . . . in three or four years at most, when *Miserere & Guerre, Fleurs du mal, Passion, Cirque*, etc., will have at last been published, they will proclaim me ready for the *Institute*, thereupon they will arrange an exhibition of paintings and will declare me the conventional follower of Cubism and more and more a man of the past. I am not saddened by this.

Georges Rouault.

LETTER 182

Hotel de Paris,
Monte-Carlo

Easter 1929

I have managed to escape and have been thinking here

quietly about the proposal which I discussed with you.

I like the subject very much. The curtain rises only once in *The Prodigal Son*. I do not talk about it to anybody, but somehow I find that quite a few people know about it already — same decor from beginning to end.

I intend staying here until the end of the Easter holidays, it is a real rest for me; at the same time I do not neglect my work. The weather is fine, and I have got rid of my flu which itself is a great blessing.

I grasp your hand in friendship. I hope to see you soon my dear Suarès.

Georges Rouault.

LETTER 184

Paris 1929

Dear Suarès,
Horror! still under the knife of the guillotine.

1 No news about the Russian ballets. I would so much like to see all that come off. I have the feeling that it will all fall on my plate and that I will have to spend many nights on it.

2 I have finished so that a first book could be published at last: 40 compositions, possibly 50 wood-engravings, and Aubert is waiting for me . . .

Then I sit up far into the night — and anyway, I already come back home late from porte Orléans.

I do not see a glimmer of hope except after the end of the month

Best regards, I grasp your hand with affection, and beg you to keep me informed on the outcome of your case. I am at your disposal should you need me, in spite of everything I have on my plate, keep me informed.

Georges Rouault.

LETTER 185

Paris, 1929.

Dear Suarès,

I am writing to Diaghilev to send you tickets, not for Thursday June 6 (too short), but for Wednesday June 12. It is the last performance.

I —	*Le Bal* by Chirico)
II —	*The Fox*)
III —	*The Prodigal Son*) 8 o'clock evening.
IV —	*Dances of Prince Igor*)

We shall talk about it later. I have never been so harassed before.

I am saddled with so much all at the same time for the beginning of June, fortunately the heat is not so unbearable.

. . . Regarding the wearing of tails I can tell you that I once went there in an ordinary suit, true, with a white collar and a little black tie. Should you have any difficulty, enquire for M. Diaghilev in my name and do not, like last time, leave with your ticket

For *The Prodigal Son* I am making, as they say, a few restrictions regarding the main part. I sent a long letter to Diaghilev about this.

1) Directions have been imposed on me by the horrible stage hands. The tent on my sketch was like a bird falling from heaven, but now it hides my decor for a great part of the production. They made a sentry box for soldiers out of it — luckily a bit squarer — so that I had to spend three nights repainting it so that it would not look too horrible. There is also some trouble about a railing — choreographic.

2) Chirico has painted all his decors over there in Monaco and had every one at his beck and call. I, when I returned here, had to leave the wardrobe-hands to carry

on in Monte-Carlo and the choreographers to work on
their own. Once here in Paris: (impossible) to change . . .
it was two or three days before the production. In my
opinion the author of the libretto should be the
choreographer as well as the scene painter.

Au revoir, dear Suarès, I am smothered with work until and
including the 15th of June, but have on the other hand had
very good results with the engravings which dragged
lamentably.
I grasp your hand with affection.

Georges Rouault.

LETTER 186

27.8.1929.

This, my dear Suarès, is what I ask you to read
I have the great honour if I stay (in the Museum G. Moreau)
of being part of the Commission and of being appointed
Honorary Curator at a special ceremony Nothing I have
proposed during the last thirty years has ever been accepted
and I am profoundly disheartened
I can tell you in confidence that I have always suffered
horribly in this museum
Do you realize that I shall be leaving with great honours and
after that be absolutely free to think as I please . . . and will
not have to be bothered to exchange compliments or observe
etiquette which always irks me.
I add to this letter a line for Dufresnoy, you have only to add
your letter to it if you will be so good as to write one.
I hope to receive your news soon. I am sorry to have to write
to you about the museum just now in view of the situation in
which you find yourself.
I grasp your hand with affection.

Georges Rouault.

LETTER 189

November, 1929.

Dear Suarès,
 . . . The horror of being dispossessed materially and spiritually . . . I understood your letter very well, if only I could be of use to you, search for what you want and send it on to you — my poor wife has just performed a tour de force for me which I will explain later. She was of immense help to me over here where she has remained — she has given proof of such humble and hidden devotion — she, who is so reserved and shy, was obliged to play an active main role. Do not be afraid to ask a favour, Suarès, and we will do whatever we can with joy; but there you have a proud nature, which is why I like you so much — one has to guess and do all one can to find a way — a subtle and ingenious or cunning way of giving you a little joy . . . you must admit it is not easy

Georges Rouault.

LETTER 191

Postcard dated 1929.

 Until Wednesday next I am snowed under with work — with the exception of tonight when I go to a concert. It is important to do this from time to time in order not to become completely stupid.
 I grasp your hand affectionately.

Georges Rouault.

H

LETTER 192

Paris, June 1930.

Dear Suarès,

We may not be able to see each other before your departure.

I talked to Vollard about you concerning *Rabelais*. He is going to consult experts!

You are authorized to inform him, in the best possible way, on the best version.

Summary

1. I need a contract — publication: 9 months before the last work is ready for the press (or one year, at the most).

2. I do not let anybody pass before certain publications of mine (some which have been ready for the press, date from 1916-18, it would be an open door for the whole aviary).

3. Kindly correct *Cirque & Passion* as soon as possible, which by the way you do very well, and forward them on.

4. I am anxious to take up many of my unfinished paintings again, that is the final aim which M.A.V.* does not seem to grasp and which is both in his material interest and in my spiritual one, please seize the opportunity of having a word with him about it.

Believe, my dear Suarès, to be always affectionately yours,

Georges Rouault.

*A. Vollard.

LETTER 196

Saint Malo,
Place Chateaubriand, 1931.

To Mr André Suarès,
11, bis, rue de la Cerisaie — PARIS (Seine).

Dear Suarès,

I was not aware that you had left Paris and above all that you had not yet delivered the end of the book. You know that if we drag on, this could play a very unpleasant trick on me, which would be too lengthy to explain to you here (I am sure that I have already told you about it).

I was foolish enough to give 22 drawings (wood-cuts) to Aubert, before leaving. I should never give anything but the entire book and thereby avoid verifications, counter-verifications, divers inventories, loathsome things, which sometime make me waste whole days.

I do not know whether you will be away from Paris for long, as for myself I am almost certain to return by mid October: do not slacken. I am writing in the same vein to A. Vollard, *Passion* must follow immediately

From October 1930 to August 1931 I worked like a slave without a day's break — but come what may I want to stop doing this and not work in this way again at any price. Therefore, please help in every possible way.

A. Vollard tells me that there are only twenty pages of the book missing

I have just come away, for 24 hours to Mont St Michel. I prefer its countryside . . . and the architecture of certain spots, to the historical or pseudo-historical stories related by the guides.

In every commercial exploitation, even of the most sublime subject, there is always some element of ridicule

For a moment (if you agree) I thought of putting a little explanatory note in the two books *Cirque* and *Passion* of about ten or twenty lines, at the most one or two pages.

You know how this has come about: I gave you some

some of the original. You have talked about them

It is, so to speak, the first time that this has been tried: giving engravings to the author. Tell me what you think of it my dear Suarès?

I hope that you are in good health.

I grasp your hand in friendship and kind regards.

Yours,

Georges Rouault.

LETTER 198

Paris, 9.3.1932.

Dear Suarès,

I would be glad if you could expedite *Passion*, we would then have the two books ready at about the same time, which would be better.

I had to make a great effort in view of the delay caused by my accident (fracture of the collar-bone).

I think I shall have finished the wood-engravings of *Cirque* soon, but will be saddled with them if I do not deliver them on the date given, but you will realize that I was anxious to 'look after you'.

I told A. Vollard that it is better to finish *Passion* before you go on holiday, more practical.

I hope that you are in good health.

I have still a millstone round my neck for reasons which you know; help me a little by saying (I am sure you share my opinion) that it would be better to finish it rather than start other works, because for the last three months they keep on saying that it was on account of the paper . . . which must have arrived by now . . .

On the other hand it has been agreed that I have the right of priority for all the work that I have undertaken since 1916-18 — and that M.J. and A will not interrupt the work — for others to worm their way in.

I will see you as soon as I have a moment, but I am tied until

the end of the month. I have had a lot of trouble and it seems that I will not have the complete use of my arm for another three months in spite of the massage.

Mon meilleur souvenir.

Georges Rouault.

LETTER 199

Paris, 23.4.1932.

Dear Suarès,

I am very pleased to have your news — I am sorry it is not better.

. . . I am looking forward (having given the whole of *Cirque* to M. Aubert) to seeing you at last on Thursday 28th April in the evening at about 8.30 — for I am still rather weighed down with work.

. . . Kind regards . . . I shake your hand in friendship.

I have not yet got over my double fracture, though I am glad to have come through it with, as it seems, such small cost to myself, but I find that my hand and the nerves of my fingers are less sensitive.

Georges Rouault.

LETTER 209

Paris, 8/12/1933

Dear Suarès,

I am afraid of making a blunder, as I have just talked to A. Vollard.

But things are not at all as I feared

A. Vollard is not the great culprit. Nevertheless talk to him if you wish — but the large printing press is always completely at our disposal; there is a slight delay at the moment — but

LETTER 216

Prieuré de Villcerf
(Seine & Marne),
21st August 1934.

Truly, my poor Rouault, I am sorry for you having to live such a troubled life, with drudgery, delays, worries concerning your craft, boils and nervous tension, which is the result of it all. Luckily you are trained to the hard business of living and resisting: because we are born to persist. Resistance and battle are but one. To be oneself and to remain so is the greatest discipline.

All corrections have been done. Do realize this. Do not allow yourself to be deceived. I returned the final section of *Cirque*: the proof-sheets have gone to Jourde's address. Ask for them if they do not give them to you.

I do not know what more Vollard can ask me. I have not seen him for the last three weeks: he came to my home on the very day of our departure. I am waiting. But what a fuss. Will it never end? If I meet him soon I will urge him in the way we both desire.

The air is fresher. It is already like autumn. You will not find a silkworm in your loft* anymore. Work without too much pain: that is my wish for you.

Yes, it is about time for you to be set free, but this can only be done if you break the shackles yourself and throw off the yoke of drudgery.

Toujours bien à vous avec affection.

André Suarès.

*Vollard had two large, well-lit studios constructed in his town house in rue Martignac. Rouault worked there for about ten years. He felt obliged to paint there even during dog days and suffered cruelly on account of this.

Paris 14/9/1934

Dear Suarès,

Are you still there? I have not left yet, I have not got *Cirque*.

I am somewhat anaemic — and I will not be able to leave until the day A. Vollard has his share of the paintings.

That exhibition at the Avenue Georges V* has dealt me a disastrous blow, because it does not leave me in peace: "I hope that the next one will be here" . . . he said.

I am practically sure that if I do not perish . . . that if I should leave and hand him over the lot, I would find it on my return unchanged.

Also once the paintings have been delivered, I wash my hands of them.

And of the responsibility which I am not going to take upon myself either to prevent or facilitate other exhibitions elsewhere. Once the lot is delivered, they should leave me in peace for a little, whatever happens.

I should have *Cirque* by the end of May — but it seems there is not much longer to wait for it anymore; it is the end and I have seen the proof-sheets but I refuse to make a single book under these conditions in future. Tell me, what has come out since 1916?

Reincarnation! . . . and like *Cirque* with how much pain

We have put our foot in it .

I know it's many reasons.

And the battles you mention are all very well, but I have a horror of continuous and useless little struggles and also above all of the power of inertia . . .

One spends oneself and uses up one's energy often without much result.

Mon meilleur souvenir.

Je vous serre la main affectueusement.

Georges Rouault.

*Exhibition organized by the Princess Bassiano.

Somebody has asked me whether there is a boarding-house in your priory. I replied: it was neither a convent nor a boarding-house, but a priory, in order to save you any bother from the said person .

LETTER 221

Le Prieuré de Villeert,
The 30th September 1934

Why are you worried, my dear Rouault? I consider it propitious that A. Vollard made up his mind to finish with it, provided that he keeps to this. You yourself will be liberated. Do not say that you are wedged between the tree and the bark. Not in the least: I always side with you and if you recollect you will find that after each conversation, A. Vollard is better disposed towards you. He does not take our lives into account, that is the trouble. As far as you are concerned, he thinks that you ask more of yourself than he does of you. He is not absolutely wrong, you must confess. The real artist is like that. The most difficult thing is not to create, but to relinquish at last what one creates; because fundamentally one is never satisfied enough to decide that one has finished. One always dreams of something better.

The only thing missing from our *Cirque* is the Table

In just over a week's time I shall be back in Paris. We shall meet soon. I hope your health is not bad in spite of you having passed the whole summer in Paris. A doctor told me three months ago: "The air in Paris is good and is equal to that anywhere." He prescribed me a cure which nearly killed me, for six weeks; and that is how I passed a wretched month, a frightful August, in spite of being in the country.

Au revoir, my dear Rouault.

Let us dwell on the eternal life, if possible; and let us ignore

the trifles of this one.

Always yours with my old affection.

André Suarès.

LETTER 222

Paris 16/10/1934

Dear Suarès,
Did you ask A. Vollard, Jourde or Mr Heine (whose address I sent you) for the table of contents where parades appears twice — for correction; I think you must have received my last letter.
A. Vollard suddenly wants (I was unwise not to have left in August) paintings, etchings, in black and white and in colour? . . . And what else? original wood-engravings! Hundreds of them he thinks that one can make them by blowing upon them
This is very painful, to say the least.
The confusion — of everything and in everything — indicates these times of *internal* misery.
Grasp all, loose all . . . At last! He will have the paintings . . . but as soon as he has them he will ask for more without bothering himself about the load of the works in execution, which will then be going at slower and slower pace.
I grasp your hand affectionately.

Georges Rouault.

LETTER 227

Paris, 16/6/1935

Dear Suarès,
. . . . When I am less harassed I should like to bring my son

along one evening, but the boy is terribly busy, though not more than I am; the hospital, the exams . . . and so many other things keep him constantly occupied on a very strict course, which I envy

<div align="right">Georges Rouault.</div>

LETTER 229

<div align="right">Paris, 27/10/1935</div>

. . . It is no use to straining oneself so much or to kill oneself in despair because one would like to be a Mozart, a Michael-Angelo or a Leonardo. One resists or one capitulates. One struggles as well as one can. One comes to realize this more or less, as the good Cézanne used to say, or one drifts, but I repeat: our elders, or at least those I knew, created that charming atmosphere knowing how to come down to the level of the good people — without being pedantic

Perhaps you have understood from my letter that the time is serious for A. Vollard. I wish he would become enlightened, amend his way, become fairer, if possible, otherwise he will probably be harmed very much, including by many of those who work and revolve around him.

Apart from bouts of anger I still am the most patient of men, though very ferocious when the mark has been overstepped.

I grasp your hand in friendship.

<div align="right">Georges Rouault.</div>

LETTER 231

<div align="right">Paris, 3rd March 1936.</div>

Vollard came to see me, my dear Rouault. We talked about

you, as you may well imagine. It would take too long to write to you about it.

In short, even though he is as enthusiastic as ever about your art, he seems to be somewhat critical towards you. He seems to be intractable.

He showed me some plates and some pages of *Passion*. You have not, until now, made anything to equal them, not even anything approaching it. A single glance at the theme and values, your colour plates show a splendour equal to the most beautiful Japanese pictures of the great era.

Regarding the spirit, some appear to me to be the only religious works of our time. I am saying what I think and am happy to do so.

A bientôt and with real affection.

André Suarès.

LETTER 235

Paris 29th of January 1937
Friday evening

I shall see you on Wednesday, my dear Rouault: I cannot on Monday.

I have not seen Vollard, since your last visit, if not in a gust of wind, between two doors. He showed me your *Baptême du Christ*, a plate I had not seen before. He is in raptures about it, as he is about everything you make. One has to do him justice. Even when he is complaining about you, he praises your talent, and your works sky-high: beyond all measure. That is the sign of our time: passionate hate or idolatry.

As for the rest, he had no time to tell me anything; I do not know anything.

Adieu, my dear Rouault. Old Aubert is certainly of a breed of craftsmen that they do not make anymore. He combines the skill of his profession with an unequalled conscience.

Bien à vous

André Suarès.

Do not come on Wednesday after all, but on Friday evening February 5.

LETTER 240

Paris, December 31st
Wednesday (1937?)

You would not believe, my dear Rouault, how much your troubles alarm me. As a matter of fact mine also torment me greatly. Fate flays me to the bone, and even my bones are gnawed away by the dog. You too have a Cerberus on your back. Do not make me responsible for this, not even for any part of it. You are the guilty one: you always agree to undertake new works. Even so I reproach myself for adding to your worries. Nevertheless I cannot rid you of them. Of all those five hundred plates, wood-engravings, copper-plates, etchings, lithographs and drawings which you have to finish or make and remake, those you intend for our two books do not amount to much: I am thinking of the number, and not the quality.

But they are indispensable. Until you have finished them, the books cannot be published. You cannot in any way imagine how much it would mean to me if they could be published as soon as possible. There now, two works were finished four years ago. A. Vollard has paid less than nothing for them. One of them *Cirque* had I had it published last year, may have had quite a considerable success. At all events people would have been impressed: at the present time it could be considered prophetic.

From this, one can assess the great wrong done to me, by an open, unbiased and fair mind.

I hope to see you soon, my dear Rouault.

Yes, I certainly am expecting you next Wednesday, January 7.

All my good wishes to you and yours.

André Suarès.

LETTER 241

Paris, 25/2/1938

Thank you, dear Suarès for your letter and the book* that followed it and for the dedication.

Whilst cutting the pages I was already able to perceive its subtle, unique and humane quality.

Gustave Moreau said to me, "In troubled and confused times, when byzantine discussions are endless, one sometimes comes across certain beacons of light in the dark"

You know so well how to say it With you nothing is ever negated, nor hated or repudiated

Gustave Moreau suffered in secret, (I know it and heard him say so more than once in private) not to be able to find on his path a being of his own calibre with some understanding of his nature, not meaning a good Samaritan . . . nor a hypocritical flatterer . . . most certainly not.

Regarding Gustave Moreau (and few, very few knew him as well as I did), besides he made my task easier by confiding in me more than I ever admitted maybe ever will admit, there is the man and the artist, and I think I knew the man well; he had passed through certain cycles through which so many of

*Trois Grands Vivants, Ed. Grasset 1938. Dedication: 'To my dear Rouault, the penitent painter who is conscious of the insignificance of this world. With my affection.'

our Matuvus of novelty will never pass — otherwise how could he have become attached to me, I who was ignorant and so very withdrawn at the time, but he understood by my expression, sensing some unconfessed desires, a repressed passion and infinite melancholy which he tried to make me overcome.

. . . M. Escholier brought me luck: they are going to make an important inventory of all my work with reproductions (the same person who has completed a large documentary of *Cézanne* over many years).**

Were A. Vollard wise and desired a preface for *Fleurs du Mal* he would do well to turn to you. "He demolishes everything and starts again all the time" he says of me. What exactly does he know about it? Eh! what does he know really?

Poor Ambroise Vollard, everything is proceeding so well — and better than one would ever have expected — you will have the proof of this tomorrow. Incidentally, without intending to offend or hurt you, I might have been unable even with the best intentions to give you these proofs, crushed as I was under the manifold works, you continually burdened me with — I kept up my daily pictorial effort. Even though free to do otherwise, I never neglected painting.

. . . I very much liked what you said about Delacroix. I share your opinion concerning the exceptional musical quality of Baudelaire.

I hope to hear from you soon. Without boasting, loyal for the best part of thirty years, and always faithful in these fickle times.

I grasp your hand with affection.

Georges Rouault.

**Lionelli Venturi.

LETTER 242

Paris, the 25th February 1938
Friday evening

Certainly, my dear Rouault, our dealings are exemplary; and you are not wrong to think about it with emotion. This mutual understanding covers half our lifetime without a single cloud; and even longer, if the true life of an artist does not start before twenty. I do not think that you can reproach me for anything; and in thinking of you, I have one regret only, which I may disclose to you one day. I am not sure even about that. I am as secretive as a sober sailor.

Do not talk to Vollard about my affairs, at least not just yet. I do not want to involve you in a dispute which I have to tackle personally. I give in, because I have an unwillingness and aversion I always have had to saying anything to promote my interest. To argue about money in any way I find impossible. I am wrong, very wrong. I know it, but I cannot help it. This modesty amounts to an illness, with me a fever of disgust, the measles of shame. Everybody thinks that I am rich, because I am so lacking in self-interest, they naturally assume I have no interest to defend. And actually I pretend that I have none. And what is even better, in my inner self it seems to me that I really have none

I do not regard this attitude as being a virtue, but rather a kind of vice, a natural trend of life which my nature is unable to accept. Nobody in the world could say that I have ever asked for anything, not even for my due, neither could I bargain for my writings, nor have I ever thought of doing so

When I see you, which I hope will be quite soon, I will let you know about an offer which I have received and which concerns you as well.

I had a visit from Vollard. You were not mentioned except that I told our famous trainer of the Fauves that you work without respite, that you are weighed down with work and that in order to meet your commitments you defy fatigue until you

are breathless under the weight of so many different burdens over such a long period of time.

A bientôt donc, my dear Rouault. I grasp your hand and am yours.

André Suarès.

LETTER 243

Paris, 7/12/1938

Dear Suarès,

I have already been back for some time. I went to see A. Vollard with that pictorial inventory . . . which took many months to prepare, quite at the wrong time, my daughter Isabelle even more so. All these gentlemen were away and it was impossible to solve anything

. . . I just finished your table of contents of *Passion*. I am preparing the 20 or 21 topics of *Cirque* in the same way. I suppose that A. Vollard has shown you that table of contents.

He said he has given you What was it? The Golden Fleece? And that he is hoping to publish a first volume of *Miserere & Guerre* soon, he is desperately anxious to bring out the works after the exhibition in New York* which seems to have been a great success. I trust that his enthusiasm will develop to an unimaginable degree.

. . . There is no longer any time for nations or people to take a nap , we know something about it . . . in this tragic month of September 1938 — perhaps it had to come to that in order to make him sit up and take notice. And high time too.

As soon as I am free, there is still a millstone round my neck . I will let you know (I am working far into the night just now), should you, as I think, be in Paris.

With my best regards and affection.

Yours,

Georges Rouault.

*Museum of Modern Art, New York, *The Printed work of Rouault*, 1938.

J

Paris 13/5/1939

Dear Suarès,

I hasten to send you this card on the receipt of your book.*
At last! What A. Vollard did not think he should publish has
been published all the same

I have not yet cut your book open, I could however recognize
certain passages and could understand their significance better
in the light of actual event. But why such events had to happen
is beyond me. It only demonstrates the general attitude of total
indifference.

. . . I forgot to tell you that I am being excommunicated
from the Museum of Berlin with all other French works — sent
back here.

What honour!

As for Hitler, his horrible voice, I heard it one day — and
. . . I was obliged to run away . . . the fact is that the human
voice, even for a man who is not a musician, reveals the
personality.

Thank you for your beautiful book. *The Shadow of the
Cross* (I had a presentiment of it in 1895) . . . that shadow is a
help only to poor people who still retain in their heart a great
love for what cannot be seen nor assessed — which is why I
painted, and not for those who lay down the law, the directors
and members of the Academy of established Beauty.

Georges Rouault.

. . . I might have been 'convict' for part of my life . . .
without deviation from an inborn integrity nor selling my
indestructable spiritual freedom in which I solely believe; quite
strong, though invisible in the eyes of so many knowledgeable
people who mistake it for a whim.

But I cannot stop my ears, nor close my eyes, nor take
Berchtesgarden with its shelters and its air of a fortress for the

Views on Europe published in 1939 at Grasset (1st Ed. 1936) Dedication: *To
my old companion in arms, G. Rouault, the most religious painter of today.
With the affection of Suarès.*

poor prison where Joan languished while awaiting the pyre, nor take her voices for those that M. Hitler is hearing, nor her struggle for delivering France for the great continuous strife which will take place without end or respite, on the pretence that the Treaty of Versailles was wrong. Had it been perfect, the strife would have been exactly the same, from the moment our bureaucrats are ensnared by a written treaty, even when Hitler perching on the pedestal of excommunicated gods turns into the Great Judge of universal spiritual matters of the greatest Europe

Here we are still allowed, until further notice, to live outside the Institute and the official Salon. I ask myself whether that would be possible in some other countries. There are many ways of being enslaved

LETTER 249

Paris 31/5/1939

Dear Suarès,

M. A. Vollard has delivered *Miserere & Guerre*. I affirm that I shall write the titles or captions for it.

Have I then to leave it with you, but what if you are not in Paris, or are busy doing something else?

I would like to be sure that you have them in hand and be able to tell this to A. Vollard which is quite easy if you acknowledge receipt in the event of your not being able to see me then.

. . . For the simple people, of course, as soon as I put: Soothsayers under the two bewildered heads or: 'Who does not use make-up?' on the face of that old clown, it is regarded as literature, worse still from their point of view: as ethics, therefore, not as painting. Their frontiers in these regards or in the regions of Form, Colour, Harmony are certainly more limited than those which Messrs. Hitler & Mussolini aspired to. Poor dauber, lost in the turmoil, I am less 'Kultivé' than they think, even abhorring certain 'Kultur', but much less

opportunist and conformist than most of them, which I state with not much pride.

A line from you would inform me of whatever suits you.

Mon meilleur souvenir.

Georges Rouault.

LETTER 250

Paris, 31 May 1939

Thank goodness, the attack has long passed, my dear Rouault. Come and see me as soon as possible.

Bring the fifty-seven plates with you. We shall study them together.

We have talked about them so much already, that all we have to do is reconcile your ideas with my visions. I transpose the wording to the drawing, so that the exchange is more intimate: for me then the visions; for you, the ideas.

It is true, the real artist and genuine poet are but one. You are one and so am I. Nothing is better regulated or more legitimate. What else? What are we not? Ruthless, beasts, heartless, wicked people one cannot live with. As though it was not enough to be suspected always and misunderstood

I am expecting you on Tuesday evening, the 6th June, if you are free. I was thinking a lot about our two great books, which will be monuments. In order to finish the work I have to keep my eye on all the plates. I will tell you how to place them, those which will be part of *Guerre*, and those which will be in *Miserere*: I conceived the two books like two dramas. Everything is nearly finished in my mind and many pages have already been written. I would like to be finished with them this summer. But the work is immense: not pages but walls to cover.

I will see you on Tuesday, my dear Rouault.

And from my heart,

yours,

André Suarès.

LETTER 252

Paris, 25/7/1939

Vollard killed on the road, on the way to Trembley, my dear Rouault. He was left there all night without help or assistance. He suffered greatly, the cervical vertebrae were ruptured. All the details are frightful. I am shattered.

Did I have a foreboding of his approaching end? Did I tell you and tell you so again? Luckily for you — if I am to believe what the poor man told me only five days ago — your agreements are signed: your affairs will not be caught up in the web of an inextricable succession No one, ever, will be able to follow in Vollard's footsteps in the publishing of our work. What will happen? I dread an irreparable catastrophe. Five works of mine were put into his hands. Our two volumes, those colossus, would have been more than just books: they would have been monuments. And *Cirque* would have been published at the end of this year. While my two other poems, *Helene Chez Archimède and Minos and Pasiphaé* will not now see the light. For me it is ruin, a disaster which hits me much more in my life as an artist than in my material interests.

Your anger and your wrath, my old Rouault, will be swept away by this funeral blast. Now that Vollard is no longer here, whatever he has been, like one will discover that he was nevertheless unique. God knows whether I am talking impartially, but truth compels me to

I grasp your hand, my dear Rouault, and sincerely

yours

André Suarès.

FACSIMILE OF ROUAULT'S HANDWRITING

FACSIMILE OF SUARÈS' HANDWRITING

15 - XII - 1912.

Je verrai je bientôt, mon cher Rouart?
Je savez que je suis toujours à la maison.
Nous prendrons jour pour rendre
visite à Cézanne. Il est plus calomnié,
aujourd'hui, par ceux qui le copient, qu'
il ne le fut par ceux qui l'insultaient. C'
est la loi. Chacun ne peut faire que son
propre salut, et ne fera jamais le salut
des autres. Combien Cézanne est
religieux. c'est un berceau de l'art, qui
ne s'est jamais lassé de marcher vers
l'étoile. Adieu, mon cher Rouart; et
bien à V. .V-

Je compte que vous me ferez lire
les livres de Bloy, que je connais
à peine, n'en ayant lu que deux ou
trois.
Avez vous vu madame Letellier? Sh
m'a parlé de votre femme avec une
entière et douce sympathie.
Faites moi souvenir, je vous en prie,
que j'ai un message à vous remettre
pour madame Rouart.
 .V-

138

INDEX OF NAMES

	letter numbers
Baudelaire, Charles	14,152,154,241,239
Bonnard, Pierre	47,137
Carrière, Eugène	61
Cézanne, Paul	17,21,34,36,50,60,101,102,116, 117,119,140,143,146,229,241
Chirico, Giorgio de	185
Claudel, Paul	32
Corot, Jean Baptiste	32,119
Daudet, Alphonse	119
Daumier, Honoré	32,38,152
Dayot, Armand*	145,152,153
Degas, Edgar	32,101,138,152
Delacroix, Eugène	32,164,241
Diaghilev	185
Dostoyevsky, Feodor	164
Escholier, Raymond**	241
Floury, publisher	27,32
Forain, Jean Louis	23
Fromentin, Eugène	14,15,16,
Gauguin, Paul	32,143
Greco, el	32
Hitler, Adolf	248,249
Huysman, Moris Karl	23,99,152
Ingres, Dominique	195,101
Maritain, Jacques	69
Michelangelo	229
Morice, Charles	32
Mozart, Amadeus	229
Mussolini	249
Moreau, Gustave	2,3,25,32,34,36,51,56,81,115, 116,128,130,132,143,152,229,241
Pascal, Blaise	32
Pégny, Charles	84
Rembrandt	6,14,16,23,34,119

*Art critic, director of 'The Revue': Art & Artists in 1925.
**Curator of Petit Palais at that time.

Renoir, Auguste — 152,207
Toulouse-Lautrec, Henri — 99
Valery — 125
Van Gogh — 143
Verlaine, Paul — 61
Vollard, Ambroise — 18,21,25,27,38,45,57,60,81,94,
101,102,119,125,138,147,155,
161,165,170,192,196,198,209,
217,221,222,225,229,231,235,
240,241,242,243,248,249,252
Watteau — 119
Zola — 60